HOW TO
MIX AND USE
COLOUR

THE ARTIST'S GUIDE TO ACHIEVING THE PERFECT COLOUR

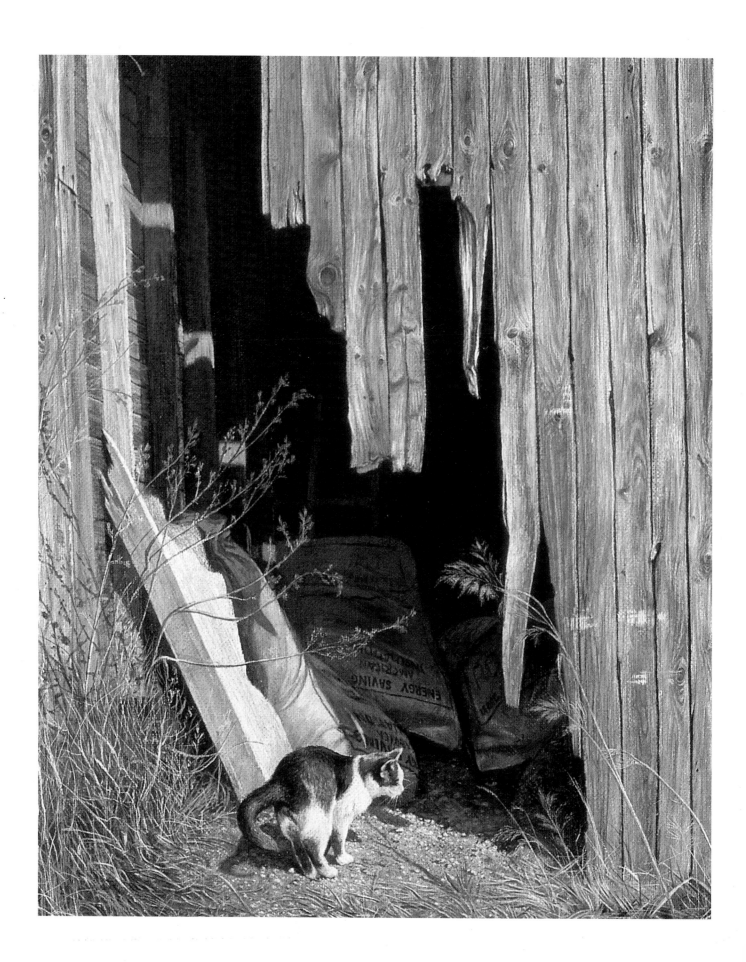

HOW TO
MIX AND USE
COLOUR

THE ARTIST'S GUIDE TO ACHIEVING THE PERFECT COLOUR

TONY PAUL

NH
NEW
HOLLAND

Published in 2003 by
New Holland Publishers (UK) Ltd
London • Cape Town • Sydney • Auckland

Garfield House
86–88 Edgware Road
London W2 2EA
United Kingdom
www.newhollandpublishers.com

80 McKenzie Street
Cape Town 8001
South Africa

Level 1, Unit 4, 14 Aquatic Drive
Frenchs Forest, NSW 2086
Australia

218 Lake Road
Northcote, Auckland
New Zealand

ISBN 1 84330 344 2

Senior Editor: Clare Hubbard
Designer: Ian Sandom
Production: Hazel Kirkman
Editorial Direction: Rosemary Wilkinson

1 3 5 7 9 10 8 6 4 2

Reproduction by Modern Age Repro House Ltd, Hong Kong
Printed and bound by Times Offset (M) Sdn. Bhd., Malaysia

See page 125 for more information on the paintings shown on pages 2, 3 and 10.

NOTE
A small number of the colours used in this book could be harmful if used unconventionally. Please read the
paragraphs headed "Hazardous" on page 43 before painting. The author and publishers have made every effort to
ensure that all instructions and information given in this book are safe and accurate, but they cannot accept
liability for any resulting injury or loss or damage to either property or person, whether direct or consequential
and howsoever arising.

CONTENTS

FOREWORD

Colour is important to all artists and as editor of *Leisure Painter* –
a monthly magazine for practising artists – it's a subject that I know
is frequently referred to in our pages. When Tony Paul approached us
way back in 1996 with an idea for a new 12-part series on colour, we
knew that it would be a popular subject, but we had no idea of the
impact it was to have on our readers. Such was its success that it
eventually ran as a regular monthly feature in the magazine for three
years between January 1997 and December 1999.

Throughout this time we received a constant stream of letters from
readers requesting the availability of the series in book form.
With vast experience of the real problems encountered by artists
gleaned from students on his courses and workshops, Tony had come
up with a winning formula and in his hands the science of colour
makes for interesting reading. His sensible, down-to-earth
descriptions and colour mixing charts reveal a whole world of colour
opportunities for the artist. Armed with an understanding of why
certain pigments behave as they do, artists are better equipped to
approach the subject of colour application with greater knowledge
as well as greater confidence.

2002 saw the reinstatement of a new 12-part series of "Colour of the
Month" articles in *Leisure Painter,* concerned with new and updated
colours, which is already proving equally popular with readers.
This long-awaited book brings together Tony's treatise on all the
colours that have been discussed in the magazine and includes
working demonstrations of each of the colours in action.

Jane Stroud
Editor, *Leisure Painter*

RIGHT View over Pollensa, Majorca;
oil on canvas; by Tony Paul. To create the heat
of the subject I used warm colours for the
buildings – cadmium red and yellow ochre –
and created the cooler, distant landscape using
muted purples of cadmium red and
coeruleum, softened with white.

INTRODUCTION

My inspiration for the "Colour of the Month" series in *Leisure Painter* magazine came from a teaching session at a watercolour class that I took for a tutor who was sick. I noticed a woman at the back of the class who was obviously becoming distressed about something. I went over to her and asked if I could help. She was mixing a vast puddle of soft green using ultramarine and Indian yellow. "Why can't I get a lovely bright green like she's got?" she said, pointing at a fellow student's painting. "I'm using blue and yellow, the same as her." I asked the other student what she was using. " Lemon yellow and phthalo blue," she answered. Turning back to the woman, I said, "Well that's the reason. You're using the wrong blue and yellow." The lady gave me a suspicious look, so I sat down and began to explain to her the different colours she could get by varying the pigments used. She said that she had never been taught this before. Many of the other students agreed and we discussed colour mixing for the remainder of the session. All of the students remarked on how valuable the lesson had been.

Feeling that this situation was not unique I suggested to my editor that I should try a series on colour mixing, using some of the more common colours. To cut a long story short, the series was successful and this book is the result.

This book focusses solely on mixing and using colour. I have explored all of the commonly used colours and also some that are less well known, but are very useful.

After a general explanation of the link between light and colour there is an exploration of colour relationships in a series of colour wheel exercises. The focus of the book is an in-depth look at the properties of the individual colours, explored in all media. In an illustrated set of colour mixes, the versatility of the colour is tested and shown and – to bring the mixes alive – a painting that uses the colour plus some of the mixes is included. My hope is that beginners and those who have difficulties with colour can improve their skills by copying the paintings, while the more experienced will put the mixes to work in their own pieces.

ABOVE After the Holiday Makers Have Gone; *oil on canvas; by Tony Paul. Cadmium red, cadmium yellow and white were the main colours used in this painting. The blues in the sea are of coeruleum blue and the darks largely of raw umber and ultramarine.*

I believe that art tuition books illustrated by a single artist are unsatisfactory as they only show the approach and "colour sense" from one viewpoint. In this book I have incorporated the work of other artists I admire and whom I feel will inspire and add variety of approach and technique.

Because I love the quality and purity of their colours, I have used and referred to Daler-Rowney colours throughout the book (unless otherwise stated). I hope that through using this book you will be released from the confusion, waste and uncertainties of "desperation mixing", being able to predict more accurately what component colours should be used and achieving the perfect colour every time. But more than this, I hope that you will enjoy the book and have fun experimenting with the mixes.

ABOVE Lynsey; *egg tempera on paper; by Tony Paul. The background is of Indian red and viridian and the face painted with touches of viridian red, raw sienna, cadmium yellow, cadmium red, alizarin crimson and coeruleum blue.*

PART ONE
UNDERSTANDING COLOUR

HOW WE SEE COLOUR

Without light there would be no colour. It is the reflection of light from surfaces that gives us the sensation of colour. Have you ever noticed that as dusk approaches you see the colours in the landscape becoming more and more subdued and that, even on a clear, moonlit night, in the low light, we see things largely in terms of blacks and greys?

How different it is on a cloudless summer's day. Colour is everywhere. The sky is a deep cobalt blue and the sea reflects it. Colours of items such as clothing, sails or brightly painted buildings glow with saturated light. Nowhere is this more apparent than in the tropics, where the brilliance of the violets and turquoises of the Caribbean Sea is unbelievable.

Light as Colour (Additive Colour)

Pure light – white light – is composed of all the colours of the rainbow. When white light is split by passing it through a prism it divides into its component colours in a similar way to sunlight passing through a shower of rain – our rainbow. Within the spectrum the main components of light – its primary colours – are red, blue and green.

Yellow comes about as a mix of green and red light. Adding green light to blue light gives a turquoise, and red and blue a purple light. Note that as one coloured light is added to another the mixed colour is lighter than both of its components. Mixing all three primary colour lights gives white light as shown in (Figure 1) below.

Different objects will absorb and reflect different colours in light (Figure 2). When you look at a red snooker ball you see the red light being reflected from its surface. All other colours, (apart from minor amounts that modify the colour say to a yellowish- or purplish-red) are absorbed by the ball.

Figure 1

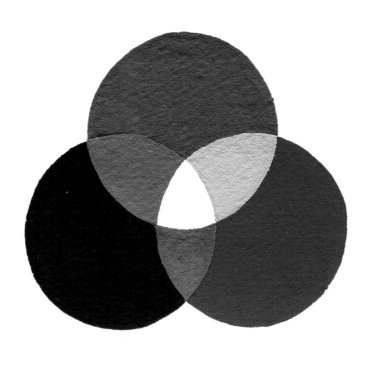

Figure 2

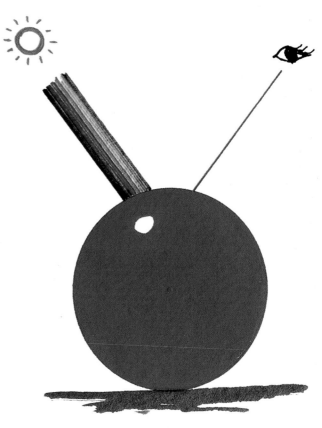

The white ball reflects all but the smallest amounts of light (Figure 1). Picture a washing line hung with white bed sheets in full sun. The reflected light can be almost blinding in its intensity.

On the other hand a black ball will absorb most of the light (Figure 2). The type of surface upon which the light falls will also have a bearing on the amount of light reflected. A polished, smooth surface will reflect more light than one that is rough. For instance, there are few surfaces darker than black velvet.

Pigments as Colour (Subtractive Colour)

Pigments do not behave in the same way as light (Figure 3). Instead of yellow coming from a mix of green and red, you get a khaki colour. This, of course, means that you cannot make yellow, so yellow, rather than green then becomes the primary colour. The mix of blue and green gives a dark blue-green, and the red and blue give a dark purple. Mixing all three gives black.

To sum up; adding light to light intensifies the light, but mixing different coloured pigments actually takes away light, ultimately resulting in black. So, in colour mixing it is wise to combine as few colours as possible if you want to achieve clean and clear colours.

Figure 2

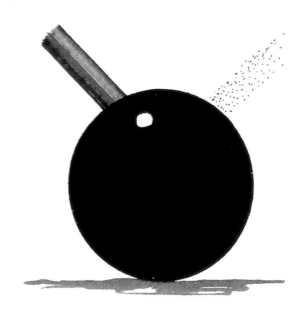

Figure 1

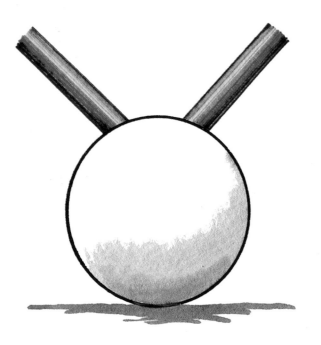

Figure 3

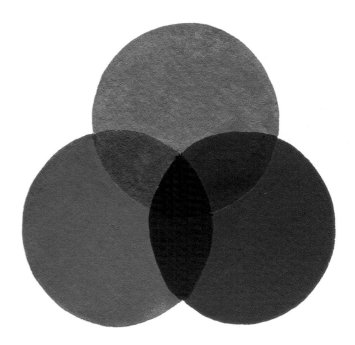

SIMPLE COLOUR MIXING

When you first start painting the decision of what pigments to select to provide a good working palette is a difficult one, given the huge array of tubes on the shelves of the art shop. If you choose a ready-filled box of watercolour pans or a boxed set of oils or acrylics, you have less of a problem as they contain a selection chosen by the manufacturer. So, the choice is made for us. This means the colour selection is adequate, doesn't it? Well, in sets of more than eight colours I think that it probably is adequate. The selection would enable you to mix most, if not all, target colours. But, with sets of eight or less, the colours provided may not be sufficient.

ABOVE This box contains eight colours. They are all useful and you could paint certain pictures with them – but they aren't versatile and don't cover the spectrum.

For a versatile box you need bright, clean, primary colours and from these you need to be able to produce bright, clean secondary colours (orange, green and purple). These will be the basis of your colour mixing. "Tailor-made" sets of eight or less sometimes lack the facility to make a good, bright purple, while including a fairly irrelevant colour like yellow ochre.

Primary Colours

Most people understand primary colours as being red, blue and yellow; but what red, blue and yellow? Reds, blues and yellows of all hues can be found at the art shop, some of which are useful, alongside others that are not.

At school we learn that red and yellow make orange, blue and yellow make green and blue and red make purple. This can be true but sometimes it isn't. It depends on the individual pigments used. A mixture of cadmium red and phthalocyanine blue makes a cool brownish colour, far removed from the vibrant purple

ABOVE Watercolours are made in tubes or pans. Pans are ideal for small work or light sketches. Tubes are better if painting larger or stronger-coloured pictures.

we might expect. Why? After all, red and blue are supposed to make purple.

Colour Tendency

There are virtually no pure colours. Some reds have an orangey character, others veer towards purple. Some yellows hint at green while others head for orange; some blues are biased towards purple and others to green (Figure 4). It is the way that these colour tendencies or biases react with one another that determines the resulting purity of the mix.

Figure 4

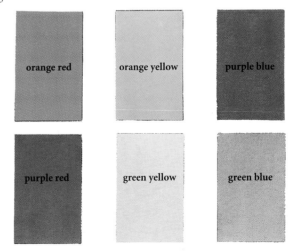

orange red orange yellow purple blue

purple red green yellow green blue

COLOUR WHEELS

The best way to explore how various reds, yellows and blues react with one another to create the secondary colours – orange, green and purple – is to make colour wheels. You need to draw circles and divide each into six equal wedges. The aim is to see exactly what the primary colours will do. The kind of secondary colours that you get will depend on what primary colours you have used. In each case I have put a yellow at the top, with a red lower left and a blue, lower right (Figure 1). The orange, purple and green are mixed between them.

Figure 1

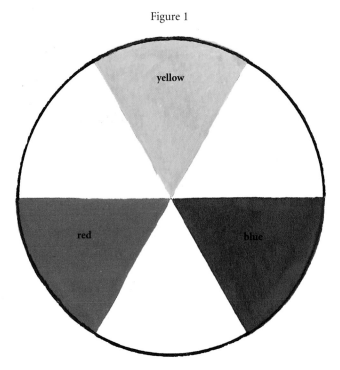

Figure 2

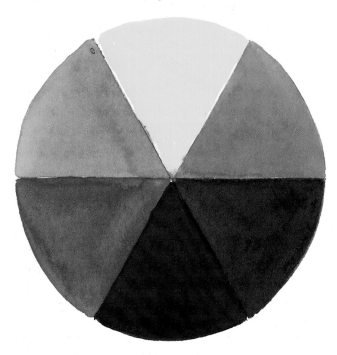

Figure 2
In this wheel I used cadmium lemon yellow, permanent alizarin crimson and Prussian blue. If the aim is for bright secondaries we are largely disappointed by this wheel. The brightest mix is the green – the colour being sharp and fresh, but the orange is more of a light brown-tan and the purple more a deep brown.

Figure 3
Cadmium yellow, cadmium red and French ultramarine were used in this wheel. It is equally disappointing if we were expecting bright colours. This time, the orange is the only colour that is vibrant. The green is soft and olive and the purple a rich, deep brown.

Figure 3

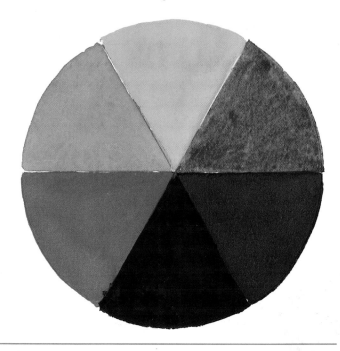

Figure 4

I was determined to get a brighter purple, so I changed the colours again. I kept the ultramarine but changed the yellow back to cadmium lemon yellow and the red to permanent alizarin crimson. At last, a nice purple, but the green, although sharper than that of Figure 3, is still soft and the orange, as in Figure 2, is brown-tan.

Conclusions

If you look closely at the component colours you can begin to see the way colour tendency affects the mixes. In Figure 3 the red is cadmium red and the yellow, cadmium yellow. If you look at these and the orange, you can see that there is an affinity between the three colours. The yellow is sunny and could almost be described as a pale orange. Likewise, the red is warm – perhaps an orangey-red. So, as both have an orange leaning, a vibrant orange will result.

If you look at the subdued oranges of Figures 2 and 4, you can see that the yellow is trying hard to be greenish, while the red would love to become purple. No wonder a rather brownish-orange is the result.

Moving on to the greens. In terms of brightness the most successful is the cadmium lemon yellow/Prussian blue mix in Figure 2. If you look hard at these two, you will see that both colours lean towards green – therefore a clean green results. With Figure 3, the cadmium lemon yellow longs to be orange while the French ultramarine is sympathetic to purple. Figure 4 is a little better. Cadmium lemon yellow is happy to become green, but the ultramarine is still steadfastly purple.

I think that you can probably work out from the above why a bright purple only results from the alizarin crimson/ultramarine mix. In Figure 2 the greenish tendency of Prussian blue destroys any chance of a vibrant purple and, in Figure 3 the cadmium red does the same because of its affinity with orange.

It would be wise to keep these colour wheel exercises for future reference, and do make sure that they are labelled clearly with the names of the colours that you have used. There are few things as frustrating as finding the hue that you wish to use in your colour wheel, but not knowing what the pigment is or, in the case of secondary colours, from what component colours it was mixed.

If you want to put the colours you have discovered through your colour wheels into practice, why not look for a subject – a simple still life would be a good choice – and paint the subject using only red, yellow and blue, but pick the nearest primary and secondary colours. It is

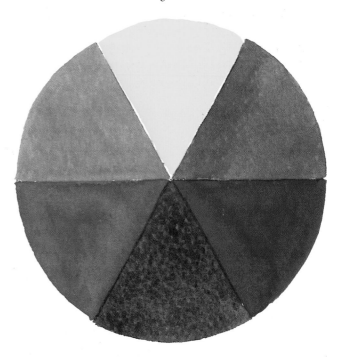

Figure 4

more than likely that you will be able to achieve a full range of suitable colours and the finished painting will be rich in colour but not garish.

If the necessary colour cannot be mixed from those in any of the former or following colour wheels, muted colours can be made by adding a touch of the primary colour that was not used in the binary mix. Adding a third pigment to a secondary colour turns it into a tertiary (third) colour.

Alternatively, some quite subtle colours can be made if colours are mixed across the colour wheel – see Complementary Colours on page 16.

Don't be afraid to experiment with your mixes and don't worry if your primary colours don't have the same names as the ones that I have used, yours will probably be described later in the book. If the colours that you have haven't been mentioned, look at them closely and try to decide what their leanings are before you mix them. Does the red you use lean towards yellow or purple; the blue to green or red, or the yellow to green or orange? For example, mixing your red, that you suspect is purplish, with a known red-biased blue such as ultramarine should give you a sharp, clear purple. If it doesn't and the resulting mix is dull or brownish then the red probably has leanings to orange. Getting to know the biases of your colours is crucial if you wish to use colour successfully.

An Ideal Colour Wheel

By now I expect that you are thinking that there cannot be any three primary colours which will give satisfactory bright secondaries – but there are. Printers have used these, in conjunction with black for years. They know them as yellow, magenta and cyan but, in artists' paint, colours of similar hues are lemon yellow, permanent rose and phthalo blue (red shade). From these three a full range of colours can be mixed (Figure 1).

Figure 1

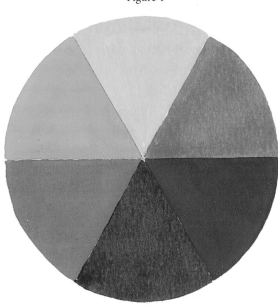

These colours are extraordinary. They are all made from synthetic organic pigments and all three are versatile mixers. Although the lemon yellow (arylamide) used is greenish it will make a clean orange with the otherwise purplish permanent rose (quinacridone), and despite the "red shade" tag, phthalocyanine blue seems equally happy to make sharp greens or purples.

Using the reds, yellows and blues of your own paints, why not see what they will do in terms of colour wheels?

Dull Colours

If you have completed the colour wheel exercises you will be able to make clean, sharp secondary colours. However, you may have formed the idea that the creation of vibrant secondaries is the only aim and that any of the other colours are "wrong". Well, nothing could be further from the truth. None of the mixes in the colour wheels are wrong unless, of course, you end up with a colour that you had not expected.

Indeed, most of the duller or softer colours will be of more use than vivid purples, oranges or greens. Although it is essential to understand how to make bright, vibrant colours, you may find that some of the other, more subtle, colours in the circles are preferable and more versatile – particularly the greens.

Complementary Colours

It is a fact that you cannot mix bright, clean colours from duller ones, but you can make some wonderfully subtle hues from bright colours by adding some of their complementary colour, rather than by adding black, which just dirties them.

Figure 2

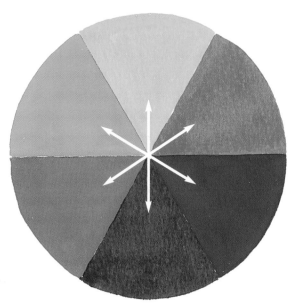

The complementary colour is the one opposite in the colour wheel (Figure 2). For instance green is the complementary colour to red and vice versa. Yellow complements violet and orange and blue will dull one another beautifully.

A small amount of a colour added to a larger quantity of its complementary partner, is useful for knocking the hard edge off a colour, and making it gentler on the eye. The more visually equal the combination becomes, the more neutral the mix will be. Warm reds and greens will create dull browns or muddy greens, while colder colours may veer more to greys or blacks. What you are actually making is, of course, a tertiary colour, as the secondary colours will themselves be composed of two colours.

Warm Colours

For this colour wheel (Figure 3) I used the yellow – gamboge hue, the red – vermilion hue and French ultramarine blue. As the red and yellow have a leaning towards orange, they make a strong, vibrant orange. The green and purple, however, are somewhat subdued. The purplish undertone of the blue argues with the yellow, while the yellow's orange bias fights the blue. The result could never be a sharp green. Instead it is a soft, sage green, far more useful in landscape work than the sharp green obtained when green-biased blue and yellow are used.

Figure 3

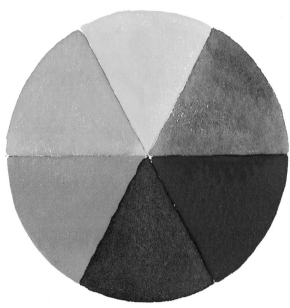

The purple is more of a purplish brown. Although the blue does its best to make a purple, the red's orangey quality counters this and subdues it. Although clear purples are very useful in all subjects, there are many instances where this dark, rust colour could be used. The one link with all the secondary colours is that they all have a warm glow.

You will be surprised at just how useful the majority of these muted colours can be. If the parent colours are used throughout the picture the painting will have a kind of unity, as all the various colours in the work are relatives and will sit together comfortably.

Cool Colours

In a colour wheel where cool colours are used – greenish lemon yellow, purplish red alizarin crimson hue and greenish manganese blue hue – you can see immediately that the secondary colours are very different. The orange is duller and more astringent. Clearly the green in the yellow has wrestled with the red and the purplish tendency in the red has opposed the yellow. The result has to be a more subdued colour.

Figure 4

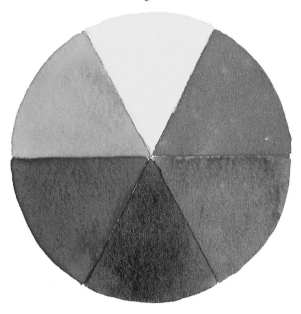

The green is bright and cold. Both manganese blue and lemon yellow have greenish leanings, so there is no conflict and they harmonize to create a clean secondary colour. When it comes to the purple – if it can be called that – we are again partly in conflict. Although red (which here leans towards purple) and blue makes purple, the blue itself has green leanings. This greenness is opposed by the red, thereby dulling it somewhat.

See how cool the colours of this wheel appear in contrast to the wheel of warm colours on the left. You can use this warmth and coolness in your paintings to great effect. The warm colours are good for creating sunlit areas or for paintings that need a cosy feel, whereas the cooler colours are good for shadowed areas or winter scenes.

Muted Colours

Interesting colour wheels can be created with duller reddish, yellowish and bluish colours. These often make useful secondary colours and, being only mixes of two colours, although fairly subdued, they will be clean and subtle.

Warm colours: In this wheel (Figure 1), I used raw sienna, burnt sienna and indanthrene blue. You can see that the raw and burnt sienna mix is, predictably, a warm, light tan rather than an orange. To say that the leanings of the siennas were towards red would, perhaps, be inaccurate. Although there is a hint of red in the burnt sienna the raw sienna's emphasis is certainly more tan. I would say the overall tendency is towards tan.

Figure 1

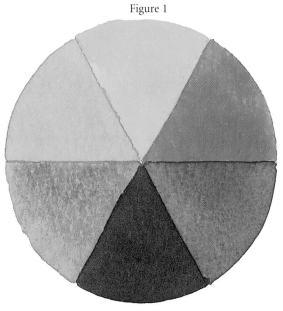

This tan quality evident in the raw sienna is not at all compliant with the purplish element of the fairly dull indanthrene blue. The purple opposes the yellow and the blue opposes the tan, so the resulting green is olive in character. This is a useful shade, particularly in landscape painting and although it is not bright, it is full and rich.

Against the indanthrene blue, the burnt sienna looks quite orange. We know that blue and orange will neutralize each other and in this mix they clearly do, making a soft dark grey, rather than a purple. If mixed densely, a black will result. This won't be as stark as a tailor-made black, such as ivory, mars or lamp black, but it will have a characterful subtlety.

Diluting or mixing with white will give a range of useful greys. Adding more brown than blue will give a warm grey, whereas weighting the colour more to blue will give colder, steely greys.

Cool colours: Aureolin (yellow), Indian red and indigo blue were used in this wheel of "cool" colours (Figure 2) which produces equally useful secondary colours. Greenish aureolin combines with purplish Indian red to make a neutralized cool beige secondary. It could be described as a very muted orange and it is a rich and useful colour for the artist.

Figure 2

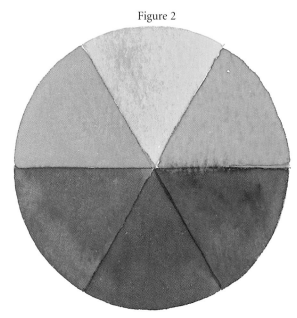

Indigo used to be made from leaves of the *Indigofera Tinctoria* plant, but nowadays it is made from various recipes. The version I used is made from three pigments: phthalocyanine blue, carbon black and permanent rose. The green it makes with aureolin is a subtle greyish-green which, again, is useful.

It is probably the wide chromatic tolerance of the phthalo pigment in combination with the permanent rose in the indigo that enables the mix with purplish Indian red to produce something of a purple. Given the dullness of Indian red and the inclusion of black in the indigo it is surprising that it achieves anything more than a grey.

Making colour wheels is a useful exercise, particularly where the less vibrant reddish, yellowish and bluish colours are used. All the secondary colours will have a rich quality as they will only be made from two colours. As with indigo, for example, where the colour is a mix rather than a mono-pigment, secondary colours may be of a muddier character.

COLOUR IN RELATION TO TONE

Without doubt one of the major flaws of much student work is the lack of understanding of tone and its relationship with colour. Where the range of tones in a painting is fairly limited there is usually little problem, but in a subject with a wide range of tones, students often have great difficulties.

In these cases much of the problem is that our range of pigments cannot reproduce the ranges of tone that our eyes see. They cannot reproduce the blinding light of the sun, neither can they quite capture the total blackness of a dark cellar. In fact our pigments can cover only 40 percent of the tones that we can see. Most of the lost tones are in the interval between pure white pigment and the light of the sun. There is no way of intensifying white paper or pure titanium white pigment to give greater brightness, so these have to represent our lightest light.

ABOVE Cats at Carnac; *egg tempera; by Tony Paul.*

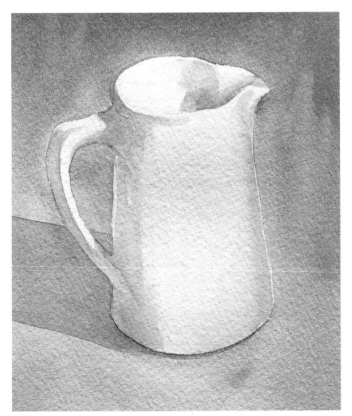

In subjects that feature bright light, such as sunshine on water, we have to step down the tones, making them darker so that the white pigment or paper read as strong light. The painting *Cats at Carnac*, shown above, is a good example of this.

In the simple example shown left, this white jug was painted in the actual tone that I saw. You can see that there are no glints of light on the rim or handle to show the gloss of the glaze. These were actually apparent but impossible to show as the colour of the jug is only marginally different to that of the unpainted paper, and the unpainted paper, or even white paint, was unable to create the sharp brightness of the glints of light.

You can solve this problem if you darken the overall tone (see painting of jug on page 20). This allows the white paper to represent the glints of light. Although the jug is clearly darker than the first example, it still appears white as the relationship of the tones of the jug, background and shadows are proportionately darker.

Arranging the tones in a monochrome painting or in subjects with subtle or closely harmonic colours is rarely difficult, but judging tones in subjects where the colours are bright and saturated can prove hard to assess. Somehow the brightness of the colour tricks the eye into believing that the colour is darker or lighter in tone than it actually is.

Another difficulty is that many students read colour as the local colour. That is to say the actual colour as if seen in bright light, without considering how it is modified by the effects of light and shadow. They can also paint what they know, rather than what they actually see. For example, when painting a portrait they make the whites of the eyes pure white, despite the evidence of their own observation telling them that the white of the eye is actually a dull grey, because at least part of the eyeball curves away from the light into soft shadow and other areas are shaded by the lids. Making them pure white creates the effect that there is a 100 watt bulb inside the head.

In the tempera *Oh For Inspiration* (shown below) the "whites" of the eyes are in fact grey. In comparison to the highlit temple they appear darker. The surrounding flesh of the sockets is, in the main, darker in tone than the whites, so this tonal difference makes the white of the eye appear as it should. Note too, that the white window frame, which is not strongly lit, still reads as white despite the fact that the sunlit flesh is paler.

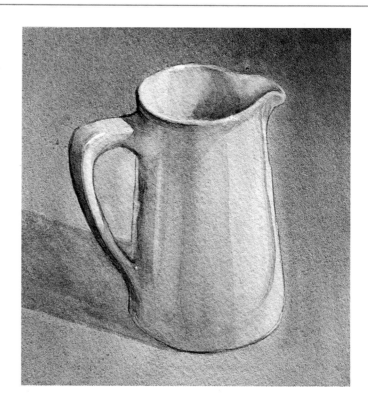

BELOW Oh For Inspiration; *egg tempera; by Tony Paul.*

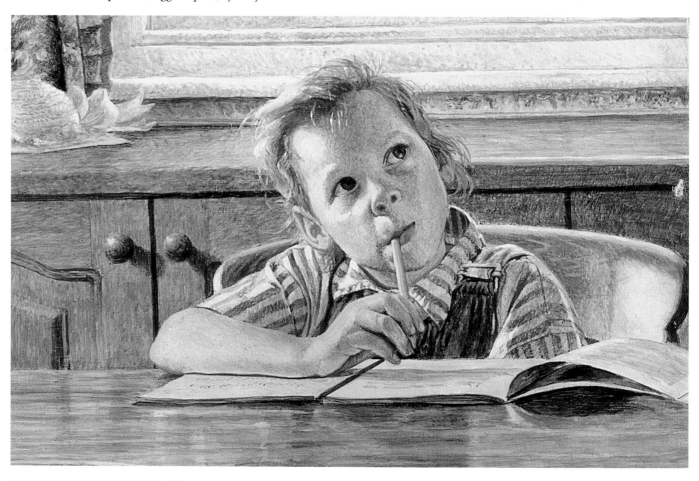

Judging Tone

Learning to judge the tone of a particular colour is very important and the following exercise will help you. You will need a sheet of watercolour paper (300gsm/140lb), watercolours, ruler, pencil, scissors and glue stick.

Figure 1

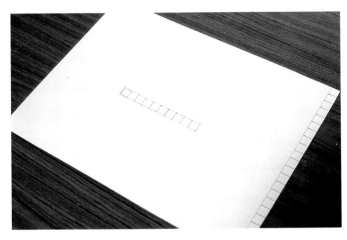

1 In pencil, mark a row of ten 1-cm (⅓-in) squares in the centre of the paper. Along the edge of the paper mark a line of about 20 similar sized squares (Figure 1). Cut this strip off and cut into squares. These will be used as coloured tiles later. The first task is to create a grey tonal scale in the centre of the paper.

Figure 2

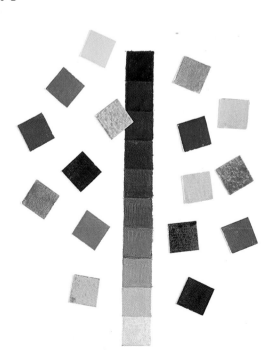

2 On the central strip, using white with just a little black added to make a very pale grey, paint the end square. Add a little more black to the pale grey on the palette and paint the next square and so on. Don't make the change of tone too severe: remember there will be 10 steps between off-white and deep charcoal grey. If you are in doubt about your ability to achieve an evenly gradated scale, have a few trial runs first. The scale itself is an exercise in tonal control, getting the gradations between the individual squares as even as possible.

3 When the scale is complete put the paper aside and, using all the colours in your paintbox one by one, paint the little squares of paper (Figure 2). Don't make the paint too wishy-washy; try to make the colour fairly saturated. Leave to dry; note that the tone of the watercolour lightens as it dries.

4 The next task is to judge the tones of the individual tile colours against the scale. If you look at Figure 3, you can see that I have used two tiles of gamboge hue and two of vermilion hue. Notice how one of each colour is lighter than the grey tone adjacent, while the other is darker. The burnt umber tile is darker than the grey tone.

Figure 3

5 Squinting through your eyelashes – an easier way to judge – try to assess the tone of a colour by moving it up or down the scale to a point where its edge against the grey is less obvious and appears neither lighter nor darker than the grey tone. (In a tonal scale of only 10 divisions you won't necessarily get a perfect match, just the nearest.) At first you will find this exercise very difficult because you will be blinded by the power of the colour, but a little practice will begin to draw the veil from your eyes.

6 In Figure 4, the gamboge, vermilion and burnt umber tiles are adjacent to the nearest tonal match. Of the three colours the burnt umber is the closest mainly because, being a dullish colour, it is easier to assess in terms of tone. The vibrant yellow and red are more difficult to read as tone.

7 Arrange all of the tiles to relate to the nearest grey tone. In Figure 5, while some tones have no match, there are others that are clustered with coloured tiles. Stick the tiles in position using the glue stick.

This tonal grey scale could be extended. If the tonal divisions were increased to 20 or more, the assessment would be much easier because, as the grey tones would be closer, the match would be likely to be more precise. Try making one with 20 gradations and using both subtle and saturated coloured tiles. Understanding the nature of tone in colour is not easy but with practice it is an indispensible tool for the painter.

To take this exercise one stage further, cut some squares of various colours, both bright and muted, from a colour magazine and try matching these against your tonal scale. Another good exercise is to take similar colour samples from a magazine and try to mix colours to match them, both in terms of tone and colour.

Please remember that if you are using watercolour, gouache or acrylic the colour or tone will probably change as it dries, so you will have to make allowances. This is a good exercise in itself as it helps you to understand the way your colours work.

Figure 5

Figure 4

Part Two
Basic Palettes

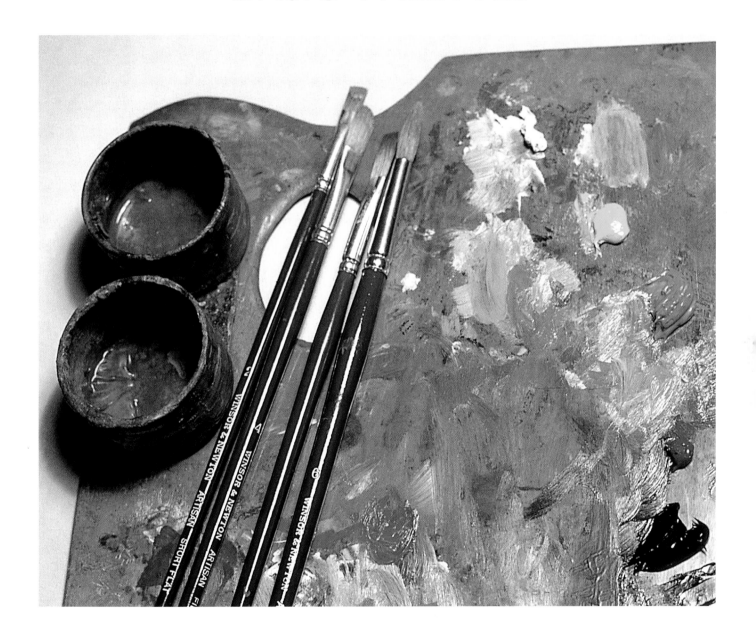

Artists' Colours

Nowadays artists have at their disposal the widest range of colours the world has ever known – colours that are not only brilliant in hue, but more lightfast than their predecessors.

As has always been the case, the industrial world provides most of the colours and mediums. Colours such as phthalocyanines – blue and green – are used to manufacture paint, particularly for cars. There are few pigments made expressly for the artist and the ones that are tend to be expensive, but are often regarded as essential.

With the development of more and more brilliant and environmentally safe pigments, many of the traditional colours are being phased out by industry, largely because of health, safety and environmental concerns.

Most lead-based colours, other than flake white (which, due to EEC directives is now sold in tins rather than tubes) are no longer available. These include the genuine chromes (lead chromate) – chrome yellows, greens, oranges and reds. This is no real loss to the artist as their permanence was always a bit suspect. Also, Naples yellow genuine (lead antimoniate) is now usually replaced by mixes of other, less harmful pigments. No

doubt, in time, the chromium greens, cobalts and cadmiums, all of which are being phased out by industry, may become more expensive. This is a shame because the latter two are particularly wonderful, and their toxicity – in relation to the difficulties and expense of disposing of the waste products – while a problem in industrial processes, is of no relevance to the artist.

Until the 1980s, the artist's palette was a motley selection of all sorts of pigments – of varying reliability, based on vegetable and animal sources – aniline dyes, as well as the more lightfast metallic oxides and salts, earth colours and synthetic organic colours. In 1976 the American ASTM standards were set up to impose uniform standards concerning labelling and the permanence of artists' paints and associated materials upon US artists' paint manufacturers. Many of the British and European manufacturers were involved in the ASTM committees and regarded this new standard as superior to their own individual standards. Most European manufacturers adopted the ASTM labelling, systematically clearing their artists' ranges of impermanent pigments and their students' ranges of any that may contain notionally hazardous ingredients. Many took the opportunity of rationalizing the entire range, reducing the number of pigments used in a mixed colour and updating their ranges with newer, well proven, synthetic organic colours, giving the artist unprecedented access to materials of the highest quality.

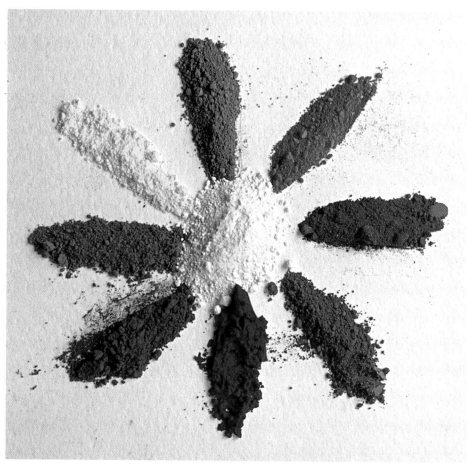

Left Most pigments can be used in any medium – oil, acrylic, water-colour, egg tempera, gouache or pastel. It is the binding medium in each case that governs the way that the paint handles.

PAINT GRADES

Paint for artists generally comes in two grades – artists' quality and students' quality.

Artists' Quality

Artists'-quality colours such as Artists' Watercolour, Artists' Oil Colour and Cryla Artists' Acrylic are made with the best possible materials, with the accent on providing the artist with colours that will stand the test of time and include the maximum amount of top quality pigment. As the costs of pigments can vary widely – from the economical ochres and siennas, to the expensive cobalts and cadmiums – the prices of the colours are banded in series: series "A" being the cheapest up to series "F", the most expensive.

Some potentially harmful pigments may be included in the range. These will be labelled accordingly. Again, I emphasize that there is no risk to the user if these colours are used in a conventional way and sensible hygiene regimes adopted before eating or smoking etc.

Students' Quality

Student-quality colours such as Aquafine Watercolours, Georgian Oils and System 3 Acrylics, are made with economy in mind. Generally the whole range of colours is given one price. To make this viable, only pigments with low or moderate cost are used; expensive colours being "mimicked" by cheaper pigment mixes, to create the mass tone of the expensive colour. This may not create the same effects as the original colour when diluted or mixed with other colours. These are usually labelled as "hue" colours – for instance "Cadmium Yellow (hue)".

Although a few of the substitute pigments may be less lightfast than the original artists' colour, this is often not the case. Many are as lightfast and sometimes more powerful. Cobalt blue, for instance, is a very expensive colour, but is fairly weak in tinting strength. The students' hue colour is made from a blend of ultramarine and phthalo blue, both powerful, lightfast pigments, but reasonably inexpensive.

In some brands second grade pigments may well be used to keep costs down. These may be less bright or clear than their first grade counterparts. Gums, resins and oils used to bind the pigments may also be second quality and the colours will often contain an amount of inert material that has no function other than to pad out the pigment. This is known as an extender or filler.

The difference between artists' and students' quality is not noticed when squeezing out the colour or using it densely, but it becomes readily apparent when the paint is diluted. It simply does not go as far or handle as well.

As student ranges are more likely to be purchased by, or for, inexperienced artists or young people, generally the entire range is non-toxic except flake white.

All this may make you feel that students' colours are a very inferior product, but this is not the case. Great care is used to create a superb product within a price ceiling. The artists' ranges are of the highest quality possible, but this is reflected in the cost of some of the colours, which can be as much as four or five times that of their "hue" counterparts in the students' ranges. Outright beginners and students attending art classes will often start by using student colours, graduating to artists' colours as their interest and painting skill increases.

Permanence

There is no such thing as absolute permanence and with regard to artists' colours this is certainly true. From the beginning of the 20th century there was a large increase in the number of colours available to the artist. Many of these were based on aniline dyes, most of which, although bright and easy to handle would fade when subjected to light. Nowadays reputable manufacturers such as Daler-Rowney have updated their ranges to exclude any colours, no matter how beautiful, that will not have reasonable lightfastness.

Fading is not the only problem. Normally excellent colours like genuine vermilion, if exposed to a sulphurous atmosphere could turn black. Chrome yellows and reds – lovely to work with and the brightest of hues – can change to dull ochres and browns. Van Gogh's sunflower paintings are an example of this. Some of the yellows used in the paintings were chrome colours. These have discoloured to khaki.

Lightfastness Ratings

A regime of testing for instability and lightfastness was eventually adopted by colour manufacturers and a code applied to the paint packaging to inform the user of the likely permanence of the particular colour.

Many companies use the star system:
★★★★ (permanent) The most lightfast and, if kept in ideal conditions, will have little or no deterioration over several hundred years.
★★★ (normally permanent) Generally relates to newer colours that may well have the same degree of lightfastness as ★★★★ (permanent) colours but as yet have not been in use for long enough to be histori-cally proven.
★★ (moderately permanent) Have either a reduced degree of lightfastness or may be unstable.

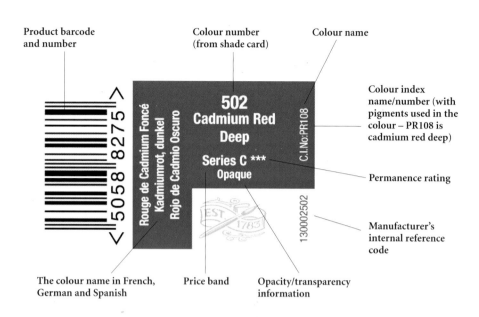

Product barcode and number

Colour number (from shade card)

Colour name

The colour name in French, German and Spanish

Price band

Opacity/transparency information

Colour index name/number (with pigments used in the colour – PR108 is cadmium red deep)

Permanence rating

Manufacturer's internal reference code

ABOVE Typical tube label information.

Framing and Hanging

All painted surfaces should be protected from the atmosphere. This can be done in two ways: either by framing the painting behind glass or by varnishing. Any varnish applied should be of conservation quality. Using domestic varnish, such as you might use to varnish a table, will darken in time and will prove difficult to remove when dis-coloured, whereas that made for artistic use will be re-dissolvable and relatively easy to remove. Should the naked paint become soiled, attempts to clean it will, in all likelihood, scalp the painting or wreck it completely.

All paintings should be kept in conditions that are as stable as possible. No matter what the lightfastness of the pigments, the painting should be kept out of direct sunlight and should not be subjected to extremes of heat or cold or changes of humidity. The visually ideal siting for your "Turner" may be above the mantlepiece of the open fireplace, but for the painting it will be disastrous, subjecting it to sudden changes of temperature, humidity and pollution by acidic, sulphurous fumes.

★(fugitive) Refers to colours that will readily fade or discolour when exposed to light.

Some colours such as alizarin crimson and several of the modern synthetic organic colours, are reasonably lightfast when used in fairly dense applications, but will fade in thin washes or when mixed with white to pale tints.

Other Factors Affecting Permanence

The craftsmanship used, the way that the finished painting is protected and the conditions in which it is kept all have bearings upon a colour's longevity. For instance, cadmium colours will fade if exposed to damp conditions. Both damp and strong sunlight or heat will cause yellow aureolin to darken to an unpleasant putty colour. If alizarin crimson oil paint has too much linseed oil added to it during painting, it will wrinkle and darken as it ages. Most formerly slow-drying oil colours now have driers added to them during manufacture. Adding a quick-drying medium to these colours while painting could result in the cracking of the paint film in time.

Egg tempera painters are sometimes advised to add vinegar to the egg medium to keep it fresher. This is unwise because vinegar is acetic acid and may bleach the ultramarine pigment.

RIGHT Manufacturers' shade card leaflets give valuable, comprehensive information about the products.

THE DIFFERENT MEDIA

The painting media that I am concerned with in this book are watercolour, gouache, inks, oils, acrylic, egg tempera and various types of pastel. All mediums use more or less the same pigments. What gives the finished paint its characteristic handling quality is the binder into which it is ground.

Watercolour

Artists' watercolour is ground into a binder made from a complex recipe based on gum arabic, while student colours generally use a blend of gum and dextrin as a basis for their binder. These binders allow the paint to be diluted to vibrant, pale washes without losing their adhesion to the paper. They remain water-soluble and, if wetted, can be lifted off. This is more effective with non-staining pigments.

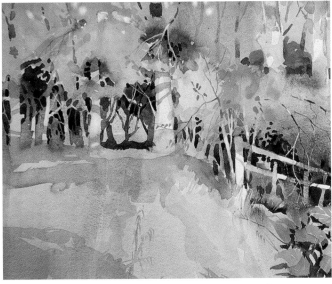

ABOVE Edge of a Wood; *watercolour; by Dennis Hill.*

In watercolour, gouache and egg tempera, each pigment particle is coated with a thin layer of binder that sticks the pigment particles to one another and to the paper or board. While this is very effective as a gluing agent, it offers no protection against harmful ultraviolet light. Watercolours, often applied in very thin washes can be more susceptible to fading than the more densely applied gouache and egg tempera media.

ABOVE A magnified cross-section through a typical watercolour, gouache or egg tempera painting.

Gouache

Gouache colours, sometimes termed "designers' colours", use similar binders, perhaps with a greater proportion of dextrin, to watercolours. These colours are rendered opaque either by packing with pigment or by adding a filler that renders the colour opaque. Again, they can be diluted to a great extent with watery washes without losing their adhesion. Being opaque, light colours can be effectively applied over darker ones, a technique that does not work in transparent watercolour.

Gouache is used by graphic designers and the range contains many beautiful colours that, unfortunately, will fade. The wise artist will avoid these colours by checking the lightfastness rating of the colour before purchase. To the designer, lightfastness has no relevance, as the artwork's usefulness will end when it has been scanned for reproduction.

In gouache, dark colours usually dry lighter and lighter colours darker, than when they are applied, particularly when white is added to the mix.

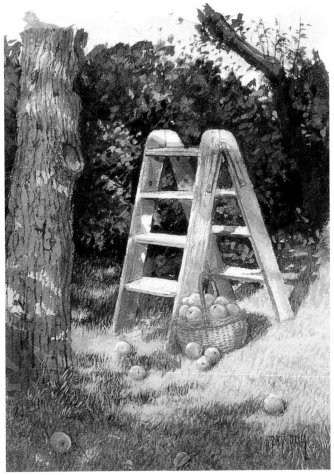

ABOVE The Artist's Garden; *gouache; by Tony Paul.*

Ink

Inks are generally bright, transparent and powerful, but the artist will need to check the lightfastness. The majority of inks are made from dyes that will fade, sometimes within a fairly short space of time. Inks made from pigments rather than dyes are often more lightfast, but even so, check the lightfastness rating of the individual colours.

The binders for inks vary. Simple dye-based inks often use shellac, gum arabic or synthetic resin, while the pigmented inks tend to use acrylic resin.

Oil

Oil colours are made by dispersing pigments in a drying oil, such as linseed oil. Unlike all the water-based media – which dry by the evaporation of the water – oil paint has to go through complex and prolonged change to achieve a hardened state. Depending on the brand of paint, the individual colour, the temperature and humidity, colours can take a few days or up to three weeks to be "touch dry".

In manufacture the admixture of oil to the pigment gives a dense, buttery paint that can be diluted with a solvent, such as turpentine, or reduced to thin glazes – the equivalent of watercolour washes – with a painting medium. Because linseed oil yellows as it ages, the whites are ground in sunflower oil that dries more slowly but yellows less.

Unlike watercolour, gouache and egg tempera, the pigment particles in both oil and acrylic paint are dispersed in a glutinous medium, rather like the bubbles in a bar of chocolate. To a certain degree, this protects the pigment from the damaging effects of ultraviolet light. Some pigments that are considered as having an unacceptable degree of lightfastness in watercolours – such as dioxazine violet – are considered permanent in oils and acrylics thanks to this extra protection.

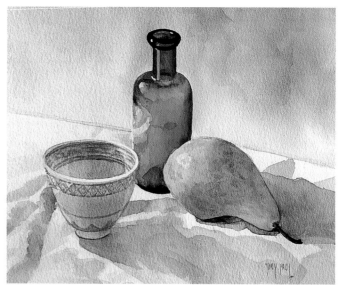

ABOVE Still Life; *ink; by Tony Paul.*

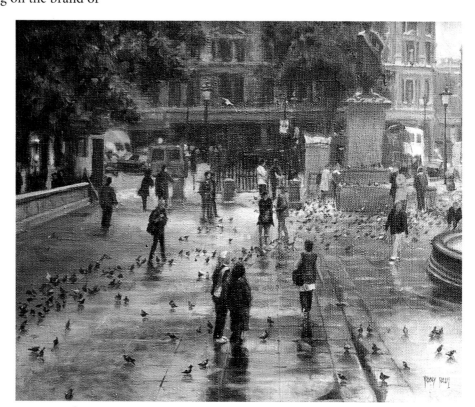

ABOVE Trafalgar Square, *oil; by Tony Paul.*

ABOVE *A cross-section through a typical oil paint film.*

Pastel

There is a partial myth that pastels are more lightfast than any other medium. Basically, a pastel stick is made from a combination of pigment and chalk, bound into a stick using a minimum amount of a binder, such as gum tragacanth. If the pigment used is lightfast then the pastel will be, but if the pigment is one that is known to fade, then the pastel will fade. The lack of a resinous binder, such as oils and acrylics have, also means that the pigment will be more susceptible to attack by ultraviolet light, although not as vulnerable as a thinly applied watercolour.

Because pastels cannot be mixed in the same way as liquid paints each colour is made in a root colour. There are also several paler "tints", where increasing amounts of white pigment or filler are added, and darker "shades" where black is progressively added, depending on the root colour (Figure 1).

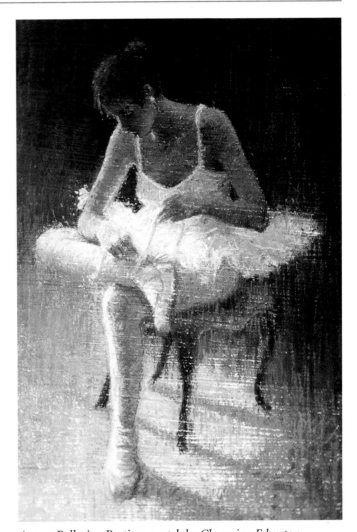

ABOVE Ballerina Resting; *pastel; by Charmian Edgerton.*

Figure 1

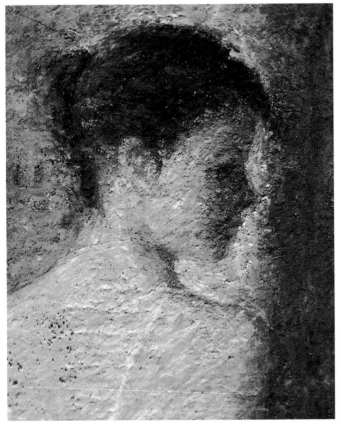

ABOVE In this detail from a pastel painting by Charmian Edgerton, we can see that pastel colours are not mixed in the same way as with liquid paints. Although colours can be mixed by the smudge of a finger, paper stump or tortillon, it is usual to lay pure colours of appropriate tints or shades one over the other in broken touches to achieve an overall colour that mixes in the eye at the viewing distance.

Burnt sienna pastel

1

2 — Tints – white pigment added to lighten colour

3

4 — Natural pigment colour

5 — Shades – black pigment added to darken colour

6

Acrylic

Acrylic colours use acrylic co-polymer emulsions as a binder. These are water-soluble and the paints can be made in two different body weights. For oil painting effects the buttery, "heavy body" acrylic paints such as Cryla work well and for thinly dispersed wash effects or "hard edge" painting, the colour dilutes easily. In student ranges, such as "System 3", the viscosity is softer than that of Cryla.

Acrylic dries quickly by evaporation to give a waterproof, elastic paint film that is much more suitable than oil for impasto work. Unlike with oils, thick and thin layers can be alternated safely and the drying time is consistent with all colours. There may be a slight change in colour as the paint dries. This is because liquid acrylic resin is milky and the colours mixed will be a softer version of the dried colour, as the resin becomes crystal clear as it dries.

Over-dilution into pale washes with plain water should be avoided, as it can lead to the pigment being underbound. The addition of a little acrylic medium to the wash will prevent this.

ABOVE How Much Longer do we Have to Wait?; *acrylic; by Alwyn Crawshaw.*

Egg Tempera

The ancient, but beautiful medium of egg tempera is, nowadays, a minority interest among painters in Europe but is more popular in America. As you can see from this book, I use it a great deal and love it for its purity and simplicity. In its most basic form it is just pigment, egg yolk and water, but many manufacturers add a little linseed oil and glycerine to improve the brushing out characteristics. It "touch dries" quickly to give a matt, almost pastel-like clarity although, if white is added to the colour mixes, these will dry like gouache to a slightly darker colour.

It must be applied thinly, traditionally in hatched strokes or small dabs of paint, but freer, more expressive techniques can also be effective. Should thick impasto be applied it will probably crack and fall off. Low impasto can be used but must be built up in thin layers with each allowed to dry before applying the next.

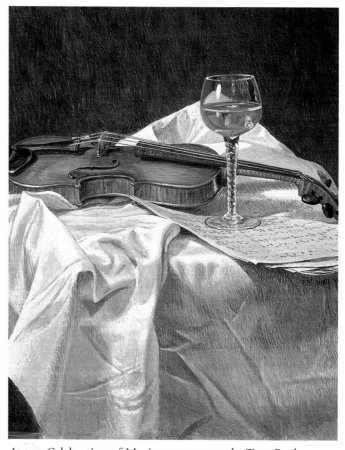

ABOVE Celebration of Music; *egg tempera; by Tony Paul.*

IDEAL PALETTES

The choice of palette is a very personal one. In a gathering of artists, few will use exactly the same colours. The following lists reflect my personal choice, but are based on versatile colours that will achieve the greatest possible range of mixes. For the different media, I have detailed a minimum palette suited to beginners or painters new to that medium who will perhaps not wish to spend too much initially, and a comprehensive palette for the more experienced.

BELOW With such a bewildering array of paints available, it is important to make an informed choice.

WATERCOLOUR

With watercolours the accent is upon transparency. Although many watercolourists, including myself, use the occasional opaque pigment, it is wise to maintain transparency as far as possible, particularly with overlaid washes.

Minimum Palette

Artists' Watercolour

Lemon yellow	Phthalo blue
Permanent rose	(red shade)
	Burnt umber

Aquafine

Lemon yellow	Phthalo blue
Crimson lake	Burnt umber

ABOVE Aquafine watercolours are an economical but good quality paint for beginners and students.

KEY

☐ ARTISTS' QUALITY

☐ STUDENTS' QUALITY

Comprehensive Transparent Palette

Artists' Watercolour

Titanium white	Permanent rose
(for highlights)	Burnt sienna
Lemon yellow	Burnt umber
Gamboge (hue)	Manganese
Raw sienna	blue (hue)
Vermilion (hue)	French ultramarine
Alizarin crimson hue	Phthalo green

Aquafine

Chinese white	Crimson lake
(for highlights)	Burnt sienna
Lemon yellow	Burnt umber
Gamboge (hue)	Phthalo blue
Raw sienna	Ultramarine
Scarlet lake	Viridian (hue)
Rose madder (hue)	

ABOVE Artists'-quality watercolours are made to the highest standards and therefore are costlier.

Additional Useful Opaque Colours

Artists' Watercolour

Coeruleum	Naples yellow
Indian red	

Aquafine

Coeruleum (hue)	Cadmium orange
Light red	(hue)

ARTISTS' INK

Originally made from animal and vegetable sources, artists' inks are now made from dyes and pigments. Daler-Rowney FW Inks are made from generally lightfast pigments dispersed into an acrylic base.

Comprehensive Palette

FW Acrylic Artists' Ink

Lemon yellow
Indian yellow
Raw sienna
Scarlet
Process magenta
Red earth

Antelope brown
Sepia
Process cyan
Rowney blue
Emerald green

Minimum Palette

FW Acrylic Artists' Ink

Lemon yellow
Process magenta

Process cyan
Sepia

ABOVE Artists' acrylic inks, such as FW Inks offer good lightfastness and strong bright colours.

OIL

Oil colour is probably the best medium for beginners, simply because it is easier to control than watercolour. Its buttery texture, strength of colour and ease of mixing are user-friendly, light colours can be painted over dark and mistakes can be overpainted or simply wiped off. With an average drying time of three days, the student painter has plenty of time to correct any errors made.

Minimum Palette

Artists' Oil Colour

Flake white	Monestial blue
Cadmium yellow pale	(phthalo)
Rowney rose	Burnt umber

Georgian Oil Colour

Mixing white	(quinacridone)
Lemon yellow	Phthalo blue
Rose madder	Burnt umber

Comprehensive Palette

Artists' Oil Colour

Flake white	Rowney rose
Cadmium yellow pale	Burnt sienna
Cadmium yellow deep	Burnt umber
Yellow ochre	Coeruleum
Cadmium red	French ultramarine
Crimson alizarin	Viridian

Georgian Oil Colour

Mixing white	Rose madder
Lemon yellow	(quinacridone)
Chrome yellow (hue)	Burnt sienna
Yellow ochre	Burnt umber
Cadmium red (hue)	Coeruleum (hue)
Crimson alizarin	French ultramarine
	Viridian (hue)

ABOVE *Georgian Oil Colours are a good choice for beginners in oil painting.*

ABOVE *Artists' Oil Colours are made with the highest quality pigments and drying oils.*

Additional Useful Colours

Artists' Oil Colour

Raw umber	Monestial blue
Indian red	(phthalo)
	Naples Yellow

Georgian Oil Colour

Raw umber	Phthalo blue
Indian red	Naples yellow

KEY

ARTISTS' QUALITY

STUDENTS' QUALITY

ACRYLIC

Acrylic colours are capable of being used in a transparent or opaque technique. In the following lists I have used a mix of transparent and opaque colours. If you require a totally opaque or transparent palette consult the relevant shade card for the appropriate equivalent.

Minimum Palette

Cryla Artists' Acrylic

Titanium white	Phthalo blue
Lemon yellow	(red shade)
Permanent rose	Burnt umber

System 3 Acrylic

Titanium white	Phthalo blue
Lemon yellow	Burnt umber
Crimson	

Comprehensive Palette

Cryla Artists' Acrylic

Titanium white	Permanent rose
Lemon yellow	Burnt sienna
Cadmium yellow deep	Burnt umber
Yellow ochre	Ultramarine
Cadmium red	Coeruleum
Crimson alizarin (hue)	Phthalo green

System 3 Acrylic

Titanium white	Crimson
Lemon yellow	Burnt sienna
Cadmium yellow deep	Burnt umber
(hue)	Ultramarine
Yellow ochre	Coeruleum (hue)
Cadmium red (hue)	Phthalo green
Process magenta	

ABOVE *Experienced acrylic painters favour the use of artists'-quality paints, such as Cryla.*

ABOVE *System 3 is the ideal choice for very large paintings, murals or where price is a consideration.*

GOUACHE

Gouache or "Designers' Colours" were very popular as an artist's medium in the 1940s and 1950s. This medium used to be widely used by designers, but this is no longer the case as they now work with pixels rather than paint.

Watercolourists use gouache to overpaint lights and to "rescue" failed paintings. They are opaque and are best used fairly densely, but impasto should be avoided as the paint will crack and may fall off.

Comprehensive Palette

Designers' Gouache Colour

Permanent white	Burnt sienna
Lemon yellow	Burnt umber
Cadmium yellow (hue)	Indian red
Yellow ochre	Coeruleum (hue)
Cadmium red (hue)*	Ultramarine
Crimson*	Process green

Minimum Palette

Designers' Gouache Colour

Permanent white	Crimson*
Lemon yellow	Brilliant blue

ABOVE *Gouache colours are water-based, bright and densely pigmented.*

ABOVE *Because gouache is opaque, see how light colours can be applied over darker ones.*

* These colours are only moderately permanent. At the time of writing these were the most permanent reds available from the manufacturer.

EGG TEMPERA

Tubed egg tempera colour is easy to use, handling somewhat like gouache. Like the latter, it touch-dries rapidly to give a vibrant, matt finish. Unlike watercolour it doesn't work very well in washes, but benefits from being built up in thin, translucent layers.

ABOVE *Egg tempera has a translucent character, falling between gouache's opacity and the transparency of watercolour.*

Minimum Palette

Artists' Colour

Titanium white	Monestial blue
Cadmium yellow pale	Burnt umber
Permanent rose	

Comprehensive Palette

Artists' Colour

Titanium white	Permanent rose
Cadmium yellow pale	Burnt sienna
Cadmium yellow deep	Burnt umber
Raw sienna	Coeruleum
Cadmium red	French ultramarine
Crimson alizarin	Viridian

Useful Additional Colours

Light red	Raw umber
Indian red	Monestial blue

ARTISTS' SOFT PASTEL

With pastel it is best to buy a set of colours sold as either "landscape" or "portrait". Both of these have a more subtle range of colours than an "Assorted" set, which contains some quite bright colours that, depending on your style, may be less useful. These all come in boxes of 12 or 36 sticks. Try to buy the largest set (or sets) that you can afford, as it will give you versatility. Any shortcomings can be made up by buying "loose" pastels at your local art shop.

ABOVE *Pastel shades – made from pigment, chalk and china clay – give vibrant colours that can be mixed by overlaying or blending.*

Oil Pastel

For those who have difficulty with the dust created by soft pastels, oil pastels are the answer. Available in boxes of 12, 16 and 24, these tend to be fairly bright in colour.

BROWNS, GREYS AND BLACKS

You should now have a better understanding of how colour works with colour and how you can predict the kind of colour a mix will achieve. It becomes more difficult as we move away from the primary colours and involve browns, greys and blacks, both as pigments in their own right and as mixed colours.

ABOVE The Abandoned Boots; *pastel; by Charmian Edgerton. See how neutral colours – browns and a variety of greys – with just a splash of brighter colour have made this subject.*

There is a good range of browns available to the artist, most of which are good colours, both in terms of usefulness and permanence. Browns range from the reddish browns, such as burnt sienna, Indian red, Venetian red, light red etc. through to the darker browns such as burnt umber, raw umber and Vandyke brown.

Many of the browns are based on natural earths although, nowadays, many manufacturers are using synthetically produced earth pigments. These "mars pigments" are often more powerful and consistent in quality. The variety of sources of a certain pigment means that there can be quite a difference in colour between one manufacturer and another. For example: one manufacturer's version of raw umber which is a mix of raw umber pigment with synthetic mars yellow is paler and greener than the Daler-Rowney version, which uses only raw umber pigment. Which you choose is really a matter of personal preference. I use both, finding each useful in certain circumstances and mixes.

There are many greys, most – Payne's grey, neutral tint, indigo, Davy's grey – are made from mixes of black and blue, with perhaps the addition of a touch of mars yellow or a deep red. Davy's grey used to be made from powdered Welsh slate, but the original slate colour is difficult to match so now, pigments are added to modify its colour or sometimes to substitute it entirely.

Blacks are made in three types: ivory black – made from burnt animal bones (originally from burnt ivory scraps); lamp black – made from the soot obtained from burning mineral oils or tars; and mars black – an iron oxide pigment. Many artists use black profusely, others do not use it at all. I am in the latter group. I find that black dirties mixes and when used alone and densely, looks like a hole in the painting. But the choice is yours.

Mixing Browns, Greys and Blacks

A variety of browns can be mixed from various proportions of red, blue and yellow, but generally speaking it is easier to mix from ready-made browns. The browns themselves can be mixed to create further browns and adding yellows, reds and greens to the browns can create some really useful and interesting colours.

Adding blue to brown produces a range of useful greys and off-greys and, in some cases, black. Mixing a dark red such as alizarin crimson with phthalo green also results in black.

Browns

Standard browns can be varied by adding other colours (Figure 1).
(a) Burnt sienna becomes a light tan when gamboge hue is added.
(b) Cadmium red puts heat into burnt sienna.

Figure 1

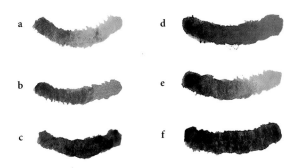

(c) Adding phthalo green to burnt sienna cools and neutralizes it, giving a fairly dark leaf mould colouring.
(d) Cadmium red gives a sultry glow to burnt umber.
(e) Raw umber is the natural shadow colour for yellow and fairly neutral mixes make useful landscape colours.
(f) Cold, neutral greens are created when mixing phthalo green with raw umber.

Greys

By using opposite colours, greys and near greys can be made (Figure 2).
(a) Mixing phthalo blue (green shade) with burnt sienna gives a soft grey-green. The greenish character is because of the green bias of the phthalo blue combining with the yellowish undertone of the burnt sienna.
(b) Ultramarine and burnt sienna oppose one another to produce a fairly neutral grey.

Figure 2

(c) A darker, cooler grey is made from burnt umber and ultramarine.
(d) A greenish raw umber and coeruleum combine to make a quite greenish-grey – very useful in landscapes.
(e) The same mix as above, but using Daler-Rowney raw umber. This is a much more neutral grey. Note how dark the neat raw umber is in comparison to the greenish version below left.
(f) Although Indian red looks similar in mass to burnt sienna, in mixes it is very different. See how the purple leanings of both the red and ultramarine create a subdued purplish grey.
(g) One of my favourite mixes for distant atmospheric hills has to be a pale wash of phthalo green and permanent rose. The soft and unusual purple is ideal to create a feeling of aerial perspective.

Neutral Colours

Neutral colours can be obtained by mixing colours that are opposite in the colour circle (Figure 3).
(a) Yellow ochre opposes violet to create a fairly neutral grey.
(b) The neutral made from a mixed orange and ultramarine has a fairly strong green character.
(c) Mixing vermilion hue with phthalo green produces a fairly neutral grey.

Figure 3 Figure 4

Blacks

Blacks can be easily made. These are slightly softer in character to the pigment blacks and can be given a warmer or cooler bias (Figure 4).
(a) A near black can be made from burnt sienna and ultramarine.
(b) Burnt umber and ultramarine will give a solid yet velvety soft black.
(c) Phthalo green and alizarin crimson combine to produce a slightly soft, purplish black.

MIXING GREENS

At some time or another, all artists have had difficulties with greens. It is hard to say why greens should be considered as more difficult than any other colour. It's probably due to the huge variety found in nature – from the sharp acid greens of sunlight filtering through fresh, spring leaves, through to the muted dark grey-green of deep shaded vegetation, mouldering after a long, hot summer. It is easy to see how students with a limited understanding of how colour works, can be completely bemused and have great difficulty in mixing the greens they require.

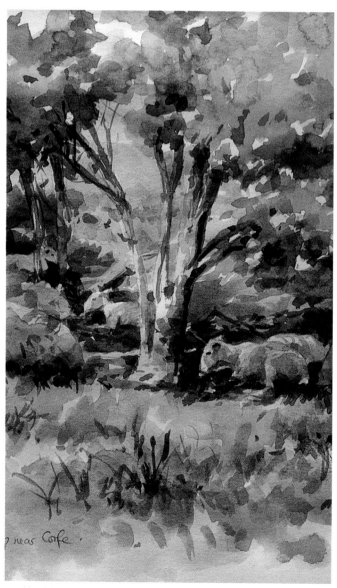

ABOVE Sheep near Corfe; sketchbook watercolour; by Tony Paul. Most of the greens were made from ultramarine and gamboge (hue). The darkest greens were made with phthalo green and burnt sienna.

Figure 1 Mono-pigmented greens

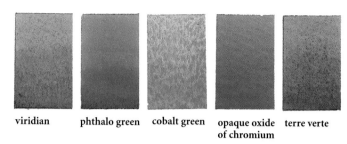

viridian phthalo green cobalt green opaque oxide of chromium terre verte

Ready-made Greens

Our first step is to look at some mono-pigment greens – in other words, greens that are not pre-mixed (Figure 1).

Viridian is probably the best known. It is a cold, blue-green, fairly weak in tinting power, but with excellent permanence. Many students, having used it neat, have found its unnatural colour totally wrong for vegetation and have consigned it to the bottom of the paintbox. This is a shame, because in mixes it can produce a large range of subtle and varied greens.

Phthalo green (also known as monestial green) is, in colour and transparency, very similar to viridian, except that it is a slightly brighter hue and very powerful. It is permanent and is found in student ranges disguised as "viridian (hue)".

I have now switched my allegiance from viridian to phthalo green, firstly for its vastly greater power (and therefore greater economy in use) and secondly because it is cheaper in price. However, it is a strong stainer in watercolour and difficult to lift off.

Cobalt green is a very expensive and weak colour. It has an unusually pale tone and its "minty" character has limited appeal. You won't reach for it much, but it can be useful on occasions.

Opaque oxide of chromium is a relative of viridian. The viridian pigment is roasted to give it opacity and a much warmer, if rather bland colour. It is useful but, in my opinion, is boring if over used.

Figure 2 Pre-mixed greens

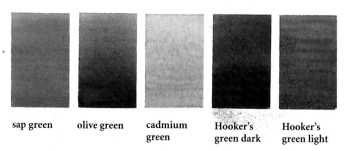

sap green olive green cadmium green Hooker's green dark Hooker's green light

Figure 3 Blue and yellow mixes

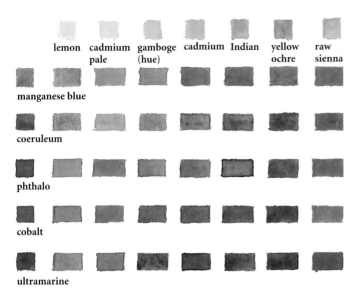

Terre verte, literally "green earth" is a dull grey-green much used as underpainting for flesh in religious painting and portraiture prior to the Renaissance. Good quality pigment is difficult to get and many manufacturers either synthesize it as a hue colour or strengthen it with other pigments. It is a weak colour and is probably still best used in portraiture, although some find it of value in landscape.

Mixed Greens

To supplement the above, many mixed greens have been produced, particularly in the watercolourist's palette (Figure 2). Although these work well, all of them could be easily and successfully made from basic colours.

Sap green was originally made from the juice of the blackthorn berry, but it faded readily. Nowadays it is synthesized from pigments such as phthalo green, deep yellow and Indian red. Some pigment combinations are of good permanence, some are not.

Olive green is almost brown. Made from various pigment combinations – perhaps raw sienna and phthalo green. Again some manufacturers' olive green will be more permanent than others.

Hooker's green comes in two tones – light and dark. Sometimes made from pigments such as phthalo blue and orange for the dark, and phthalo green and deep yellow for the light, it is a popular choice. Beware of the lack of permanence in some manufacturers' ranges.

Cadmium green is mainly made for oil painters. It is a combination of phthalo green and cadmium yellow and is more opaque than Hooker's green.

Mixing Greens

When mixing your own greens, remember that those colours that lean towards green will give brighter greens, while those that don't will offer more subtle, muted colours (Figure 3).

The blues – coeruleum, phthalo, Prussian and manganese – and the yellows – lemon, cadmium, permanent and aureolin – will give sharp, clean greens when mixed, while blues such as cobalt, ultramarine and permanent blue, in combination with yellows such as cadmium deep, gamboge and Indian, will give much quieter greens. If you replace the yellows with earth colours such as yellow ochre and raw sienna, some really muted greens can be achieved. Mixing a yellow or blue which leans towards green with blue or yellow that doesn't, will give a further variety of useful shades.

Using blue and yellow can cause problems if you need really dark greens. To obtain a dark colour you have to add a fair bit of blue, but this can make the green too cold, so you add some yellow, which then makes the green too light. In desperation you then add more blue which again cools the mix, so then you use some dark brown or red to warm it up, which means that you now have three colours and a somewhat duller mix.

For dark greens, the best solution is not to use blue and yellow, but start with a mono-pigment green. Phthalo green is an unnatural primary green. There is no yellow pigment in it: it is solely green. Therefore it will not lighten a mix. Really dark greens can be made by adding burnt or raw umber, the warmth or coolness being controlled by the amounts of brown or green in the mix (Figure 4).

Figure 4 Mixes made with phthalo green

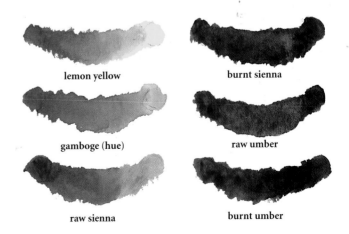

lemon yellow burnt sienna

gamboge (hue) raw umber

raw sienna burnt umber

PART THREE
COLOUR MIXING

COLOUR MIXING CHARTS—EXPLAINED

Colour Name: The colour names shown are those used by Daler-Rowney for their range of colours. Other manufacturers may use slightly different names.

Colour Index Name (C.I. Name): Sometimes pigments with difficult names—Phthalocyanine Blue (Pigment Blue, PB 15), for example—are given simpler, but often fairly meaningless names, such as Monestial Blue. These names will vary from manufacturer to manufacturer. Other colours may have "hue" added after the name. So, "Cobalt Blue (Hue)" is unlikely to contain one grain of the real Cobalt Blue (PB 28). Unless the actual pigment(s) used or the colour index names are quoted, we will have no idea what pigments have been used in the paint.

Most good artists' colour manufacturers are now putting the Colour Index Name (C.I. Name) or the pigment(s) name on the packaging and/or in the individual ranges' colour charts. So we might learn that Permanent Rose is PV 19—Quinacridone Violet.

By using the colour charts in this book and by cross-relating the Colour Index name or pigment names to your paints you will know what you are using and can predict how they will perform in colour mixes.

Colour Tiles: Tile number 1 is the colour with which other colours—in rows one and three—will be mixed. The resulting mixes are shown in rows two and four.

Permanence: This is the degree of lightfastness that the individual colour has. Nowadays, most artists' colour manufacturers relate their colours to the ASTM standards. They have carried out rigorous lightfastness tests on most pigments and grade their results as: Class I (excellent lightfastness) or Class II (very good lightfastness). Only these two lightfastness grades, (equivalent to Daler-Rowney **** and ***) are allowed to be used in artists' quality paint in the United States. The lower degrees of lightfastness—Class III (fair lightfastness)/Class IV (poor lightfastness)—are not considered lightfast enough for artists' standard paints, but some may find their way into student ranges.

Blue Wool Scale (BS 1006, EN 20105, ISO 105): This is a lightfastness test that is designed to compare the fading characteristics of a colour with samples of blue wool of known fading speed. I have used this because some colours, although reasonably lightfast when applied densely, fade more rapidly when mixed into pale tints with white or when thinly applied. The blue wool scale tests give both the full strength and the tint ratings.

Only where they differ do I quote the tint rating. BWS 8 is the most lightfast, with each lower number having half the lightfastness of the next higher. Any colour rated below BWS 6 is likely to be suspect.

Colour Bias: This is the tendency that a colour may have to lean towards another colour. For example, Ultramarine is a purplish-blue, therefore it has a purple bias.

Transparent/Opaque: Whether or not the colour will be transparent when overlaid, or will partially or completely obliterate the colour beneath.

Staining: Some colours, for instance Alizarin Crimson and Phthalo Blue and Phthalo Green, will stain the surface on which they are painted. This information is of particular relevance to watercolourists when choosing colours that they may wish to soften or lift off later. Staining colours may soften a little but will never be totally removable, so it is always best to check before you use a colour.

Hazardous: There are certain pigments that have the capacity to damage health if used unconventionally. If you were to eat these colours, breathe in clouds of the dusted pigment in, contaminate an open wound or cover your skin with them, they may cause harm.

In the modern palette most really harmful pigments have been replaced, but you should still maintain a regime of hygiene. Wash your hands after painting and before smoking or eating, never put brushes in your mouth, and avoid breathing in pigment dust.

If a painting process involves vaporizing paint or creating pigment dust, wear nose, mouth and eye protection.

When hygienic, conventional techniques are used with tube or pan colours there really is no risk to the user from hazardous pigments.

Regulations forbid the use of hazardous pigments in modern pastels as the pigment particles could become airborne and be breathed in. Take care if you are using old products as they may contain a hazardous element.

Tinting Strength: This is the power or lack of power of a colour in terms of its density or covering power when diluted. With a colour of high tinting strength—such as Phthalo Green, a little will go a long way, so it is economical in use. Whereas with a weak tinting green like Terre Verte, it takes a lot of the colour to adequately cover a small area of the painting surface.

WHITES

Strictly speaking white is not a colour, but a tinter used to lighten other colours. Zinc white (pigment white 4) is the cleanest, slightly bluish in character and best used for making colour mixes; while the powerful titanium white (pigment white 6), a fairly neutral colour, is good for obliterating under-colours and putting in highlights. Flake white (pigment white 1) is slightly warmer in hue and is only used in oil painting, where it excels. There are other whites, but most are made from the pigments listed above. All three whites have an ASTM rating of class I (excellent lightfastness), Blue Wool Scale 7 (absolutely lightfast).

In oil paint, flake white is ideal in under-painting and for mixing with the higher oil content colours. It dries rapidly to give a hard, flexible paint film and, when mixed with slow-drying colours, considerably speeds the time it takes for them to dry. A little zinc white is often added to counteract the softening of the paint film as it ages.

Titanium white is useful in oil but is not as good as flake white, having a higher oil absorption, longer drying time and giving a soft paint film. It is best in water-based media. However, it can make mixed colours look dull or chalky.

Zinc white came into the artist's palette in the early 1900s. However, in watercolour, in its guise as Chinese white, it has been in use since the 1830s. It is the least opaque of the whites, with a medium tinting strength. It is the best white for mixing colours as it de-saturates the mixed colour less than the other two. In oil it is useful for mixing with glazing colours, where its lack of opacity and pure hues are an advantage. It has a medium oil absorption and dries very slowly to give a hard, brittle paint film – best used in the upper layers of a painting.

Mixing Chart

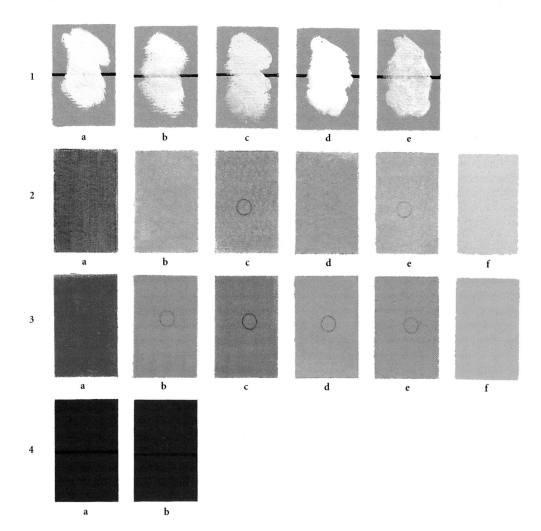

MIXING CHART

Egg tempera was used for all the mixes, except where permanent white gouache and Chinese white watercolour are specifically mentioned.

1 The covering strength of the whites is compared:
(a) Titanium white – it is dense and obliterates the black line.
(b) Zinc white is semi-opaque. It will not cover the black line.
(c) Flake white is warmer in hue and almost obliterates the black line.
(d) Permanent white gouache is made from highly packed titanium white pigment for maximum opacity.
(e) Chinese white watercolour – made from zinc white pigment – does not totally obscure the black line.

2 Both tinting strength and opacity are shown in mixes with a pigment of low tinctorial power – in this case, viridian.
(a) Viridian straight from the tube is both transparent and sharp.
(b) Equal amounts of viridian and titanium white are mixed together. The result is a chalky eau-di-nil. The circle drawn on the paper before the paint was applied is barely visible.
(c) Viridian and zinc white are mixed equally – note that the less dense white has allowed the slightly stronger green to retain much of its character. The circle is much more apparent.
(d) Flake white obliterates the circle almost as well as titanium white, yet the green appears a little fresher than the titanium mix.
(e) The semi-opaque character of Chinese white allows the circle to show through. It is more dense than I would have expected, compared to the zinc white. The soft green is chalky in character.
(f) White gouache mixed in equal quantities with viridian gives a pale chalky mint green which totally obliterates the underlying circle.

3 The whites mixed in equal quantities with a powerful colour – cadmium red.
(a) The cadmium red is rich, strong and fairly opaque.
(b) The equal mix with titanium white all but obliterates the circle. The mixed colour is a little chalky and, because of the red's strength, the white does not subdue it as much as it did the green.
(c) The difference in tinting strength between zinc white and the red is apparent in this equal mix. The red is only slightly subdued and retains all its character. The circle shows clearly.
(d) Flake white's warm character has influenced the red, giving a soft, rounded pink. The circle is just visible.
(e) The lower tinctorial power of Chinese white gives a darker pink in equal mixes. The circle can be seen.
(f) Permanent white gouache gives the densest, most opaque mix. It is difficult to believe that equal quantities of both pigments were used. The circle is obliterated.

4 White can also be used to make transparent pigments, such as French ultramarine, more opaque. It needs very little white to interfere with the light passing through the pigment. I used titanium white and, as you can see, there is very little difference in the colour: (a) is the pure French ultramarine pigment and (b) is the colour to which the white has been added.

5 The final illustrations show typical uses for the titanium and zinc white pigments: the titanium white (a) is good for catchlights in the eyes in a portrait, while the zinc white (b) has the subtlety to describe the bloom on a grape.

a

b

YELLOWS

RIGHT Still Life; *pastel; by Charmian Edgerton. A range of bright oranges and yellows were used to paint the fruit. These colours work well against the more sombre background colours.*

LEMON YELLOW (Nickel Titanate Yellow) — Pigment Yellow 53

ORIGINS

Lemon yellow is a generic term, with different manufacturers using varying pigments to create this greenish-yellow. Developed in the 1960s, nickel titanate yellow is a fairly inexpensive addition to the artists' palette. Besides being greenish, it is very pale – almost as if mixed with white. This is the reason that sharp, strident colours are not possible, the only exceptions being admixes with one or two blues that lean strongly towards green.

COLOUR MIXING CHART

1 Nickel titanate's greenish leanings can clearly be seen. The colour is pale and lightens only slightly when diluted.

2 Adding white has a slight dulling effect on the colour.

3 Adding nickel titanate to an earth colour, such as raw sienna, gives it a warmer edge.

4 The greenish leanings of nickel titanate argue with the orangey vermilion hue to make a soft, dusty orange.

5 A duller orange results from mixing alizarin crimson with nickel titanate.

6 Light red is warmed to a soft tan by adding nickel titanate. A useful and subtle colour.

7 The greenish coeruleum (cerulean) combines with nickel titanate's pale green leanings to make a soft, but pleasant, spring green.

8 Cobalt blue is fairly neutral, leaning neither to green nor purple. The result of this mix is a subdued and dusty green. A useful mix for trees in the mid-distance, the dusty quality provides an effect of aerial perspective.

9 Phthalo blue (green shade) can make quite violent greens, but not with nickel titanate. The green is rich without being crude, yet it has a vibrant and fresh

Lemon Yellow Mixing Chart

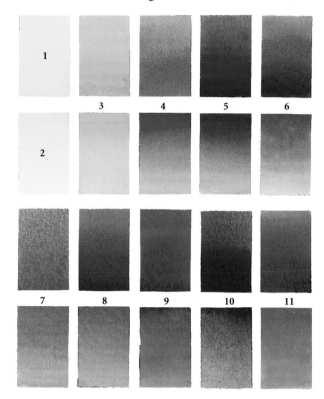

quality. The dusty character is subdued by phthalo blue's power.

10 Ultramarine never makes sharp greens due to its purple leanings and as nickel titanate is fairly dull, the resulting green is cool and almost greyish. A good colour for trees in a landscape painting.

11 Like its blue sibling, phthalo green has the power to make a bright, clean green with nickel titanate to warm it.

PROPERTIES

PERMANENCE: ASTM D4203 Class I (excellent lightfastness); Blue wool scale 8 (absolutely lightfast)

COLOUR BIAS: Greenish.

TRANSPARENT/OPAQUE: Opaque.

STAINING: No.

HAZARDOUS: The modern colour is not considered hazardous. Older colours, produced since 1978, will have a hazard warning symbol if they contain any hazardous substances. For a tube or pan that pre-dates 1978, it would be wise to treat it as having a hazardous element.

TINTING STRENGTH: Medium to low.

CHARACTERISTICS: Nickel titanate is a pigment that veers away from the sharp, bright lemon yellows of the arylamide colours that make bright oranges and vivid greens. Its mixing qualities are similar to the obsolete lemon yellow – barium chromate – being greenish, moderately weak in covering power and making subdued, dusty mixes.

WATERCOLOUR: Its opacity limits its usefulness in watercolour, but in some manufacturers' ranges it is used as lemon yellow. It melts easily into washes and mixes readily with other colours. Useful if softer colours are needed.

OIL: Nickel titanate's opacity makes it suitable for use in oil paint. It has a medium oil absorption and is a medium to slow drier. If mixed with faster drying colours of low oil absorbtion it could be used safely in the under layers, as well as in the upper layers of a multi-layer painting. It dries to give a hard and fairly flexible paint film.

OTHER MEDIA: Can be used in all media except in pastel, where the original pigment will be replaced by a hue colour.

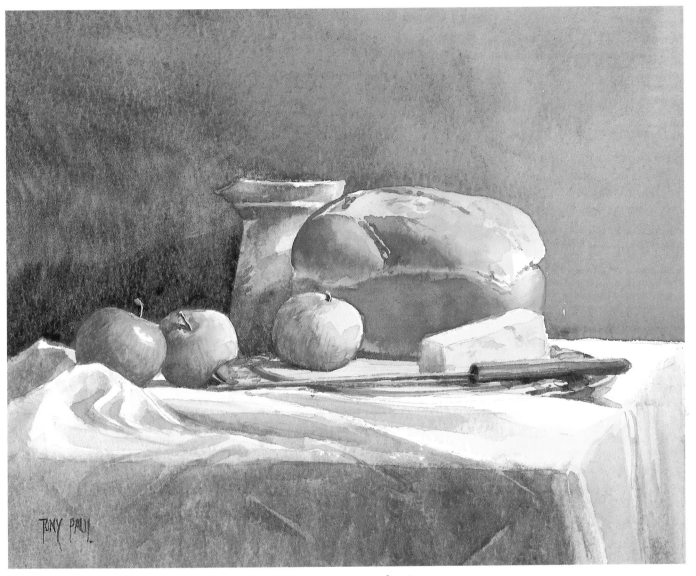

THE PLOUGHMAN'S LUNCH
TONY PAUL
watercolour; 200 x 240mm (8 x 9in)

The background on the left is burnt sienna with phthalo green to darken and cool it. As I moved across I lightened the mix and added a touch of gamboge hue. The cloth is coeruleum with raw and burnt sienna. The top of the loaf was washed over with plain nickel titanate, with wet-in-wet vermilion hue. Over the lower part of the loaf is a soft wash of cobalt blue. The cheese and the yellow of the apples is nickel titanate. The jug was painted in coeruleum, raw sienna and burnt sienna. When the washes on the loaf were dry, a nickel titanate/light red mix was washed over the brownish areas of the loaf. Where the cobalt blue was covered, a soft, dusty, slightly purplish colour was achieved. A mix of cobalt and the nickel titanate/light red mix was painted for the shadow areas of the loaf. The apples are vermilion hue, nickel titanate and alizarin crimson hue, with a little coeruleum and nickel titanate for the greens. The dark shadows and the handle of the knife are ultramarine and burnt umber.

CADMIUM YELLOW – Pigment Yellow 37

ORIGINS

Discovered in 1817, it came into general use in 1846. Most artists' colours are based on pigments used by industry and the industrial use of the cadmium colours is declining. This has had a "knock-on" effect for the artist, as these pigments are becoming more expensive. Nevertheless, they are wonderful colours – powerful, rich and creamy – of particular value to the oil painter.

COLOUR MIXING CHART

1 Pure cadmium yellow – the orangey bias can be seen. The paint goes on smoothly, covering well.

2 Cadmium yellow can be made in different hues; (a) is cadmium yellow light, with a greenish bias, whereas cadmium yellow deep (b) veers strongly towards orange.

3 Cadmium yellow and cadmium red mixed together make a clear and powerful orange. As both colours are opaque and of similar tinctorial power, mixing is easy. In oil, the slower drying red will retard the drying time of the yellow.

4 Alizarin crimson's purplish bias is in opposition to the orange bias of cadmium yellow. This results in a dullish, but useful orange. The transparency of the alizarin is destroyed by the opaque yellow, which takes some of the fire from the colour.

5 The purity and versatility of permanent rose creates a fairly clear orange when mixed with cadmium yellow.

6 Opaque, greenish coeruleum and cadmium yellow make a green that is soft and cool – the sharpness of the blue-green being taken away by the warmth of the yellow. A useful mix for foliage in cool shadow.

7 The powerful purple bias of French ultramarine ensures that a bright green will never be produced. What is certain is that very useful greens will result. The orangey cadmium yellow adds warmth to the mixed colour – useful for full summer foliage.

Cadmium Yellow Mixing Chart

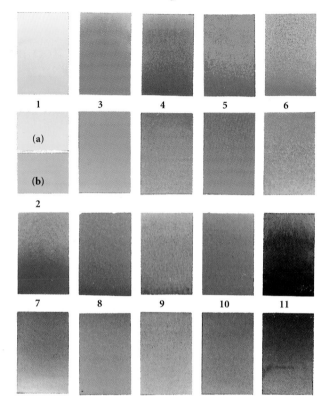

8 Phthalocyanine blue, otherwise known as phthalo/monestial/Winsor blue, has a green bias. Again, the orangey cadmium colour softens what could be quite a vicious green (had cadmium yellow light been used), into one far more generally useful – bringing to mind well-watered lawns.

9 The chill coldness of viridian is thawed by the sunny character of cadmium yellow. A spring lawn in mild sunlight, tender foliage fresh from the bud and sunlight through leaves – superb.

PROPERTIES

PERMANENCE: ASTM D 4302 Class I (excellent lightfastness); Blue Wool Scale 7 (absolutely lightfast).

COLOUR BIAS: Towards orange.

TRANSPARENT/OPAQUE: Opaque.

STAINING: Yes.

HAZARDOUS: The modern colour is not considered hazardous. Older colours, produced since 1978, will have a hazard warning symbol if they contain any hazardous substances. For a tube or pan that pre-dates 1978, it would be wise to treat it as having a hazardous element.

TINTING STRENGTH: High.

CHARACTERISTICS: The cadmium yellows are made in several different hues, from lemon to almost orange. They perfectly replace the obsolete chrome yellows in hue and are much more reliable. In student ranges, the cadmium colours are replaced by "hues", normally of the arylamide group.

WATERCOLOUR: The opacity of cadmium yellow makes it less suited to use in watercolour than in other media. Dilution will reduce its opacity but it will always appear as a veil when applied over other colours. It gives flat, even washes.

OIL: An excellent oil colour with a smooth, buttery character. The pigment has a medium oil absorption and is average to slow drying. The dry paint film is fairly flexible.

OTHER MEDIA: Can be used in all media except in pastel, where the original pigment will be replaced by a hue colour.

10 Purple and yellow are opposites in the colour wheel; therefore their mixture will produce a neutralized colour. Permanent mauve (dioxazine violet) has a reddish bias which is complemented by the orangey cadmium yellow. The result is a neutral colour, useful as a foil to stronger, purer colours. Despite its subtlety, it has a glow that would not come from mixing several colours together.

11 Black can destroy most colours when mixed with them. Cadmium yellow is one of the colours that can survive its deadly influence. The vibrancy of the yellow ensures that the colour is never entirely subdued. The resulting yellow-grey has great subtlety; a not-quite-green which, when put against a red-orange or warm brown, will read as one.

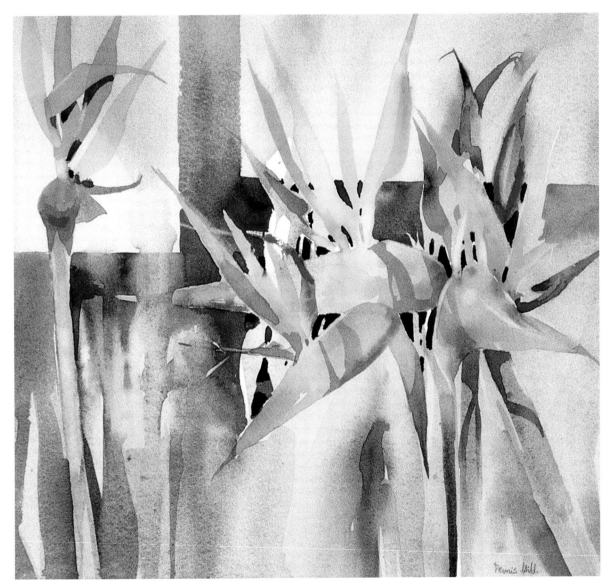

BIRDS OF PARADISE
DENNIS HILL
watercolour; 320 x 360mm (13 x 14in)

After initial wet-in-wet washes of cadmium yellow and ultramarine, the flowers were developed with ultramarine and rose madder to create oranges and soft purples. Touches of cadmium orange were added to create darker yellow petals.

NAPLES YELLOW – Pigment Yellow 41

ORIGINS

Naples yellow was thought to have been gathered as a volcanic deposit from the slopes of Mount Vesuvius in Italy, but examples of its use in the Middle East go back to the 5th century BC. The yellow varies in colour depending on source. I used Naples yellow watercolour. This is made from titanium dioxide and cadmium pigments. Nowadays Naples yellow is usually produced as a "hue". Therefore, it is important to check the lightfastness of the colour before buying.

COLOUR MIXING CHART

1 This variety of Naples yellow has an orangey hue and is fairly opaque with a dusty quality, which is transmitted to all the mixes. This is probably because of the inclusion of titanium white, which is very dense.

2 When mixed further with white – white gouache – the colour softens to a pale peach. Quite a useful colour for portrait work.

3 Adding Naples yellow to the sharp lemon yellow gives a subdued range of dull orange yellows – useful where a warm, but not over bright glow is needed.

4 The rather raw hue of cadmium orange is subdued by adding Naples yellow. A useful soft, faded orange results.

5 Vermilion hue softens and warms when mixed with Naples yellow. This colour glows, ideal for small touches in portrait and landscape work.

6 The sharp, purplish bias of alizarin crimson argues with the soft, warm orange of Naples yellow to make a powdery, cool, orange – useful for autumnal landscapes and portrait work.

Naples Yellow Mixing Chart

7 Coeruleum's greenish tendency combines with Naples yellow to produce a lovely soft green, excellent for distant landscape. The orange in the yellow gives the colour great subtlety.

8 A grey-green results from mixing French ultramarine with Naples yellow. The neutrality of this colour is caused by the opposition of the blue's purplish bias to the deep muted yellow.

9 Cool Indian red is warmed considerably by adding

PROPERTIES

PERMANENCE: (original pigment) ASTM D4302 Class I (excellent lightfastness); Blue wool scale 7–8 (absolutely lightfast). Check manufacturer's permanency rating for substitute pigments.

COLOUR BIAS: Varies from greenish through to pinkish orange.

TRANSPARENT/OPAQUE: Fairly opaque.

STAINING: No.

HAZARDOUS: The original pigment – lead antimoniate – is highly toxic. Substitute pigments may or may not be considered harmful – check on the shade card.

TINTING STRENGTH: Medium.

CHARACTERISTICS: A popular pigment for oil painters which is sometimes available in different shades. The original pigment was very good. Less commonly used in water-based media, probably because of its opacity and (formerly) its lead content.

WATERCOLOUR: It is popular with watercolourists and, used as an underlayer, can help create interesting colours.

OIL: An excellent oil colour. The original pigment was flexible, quick drying and buttery, with a low oil absorbtion. Substitute colours may vary in these respects according to their composition.

OTHER MEDIA: Naples yellows made from substitute pigments are often used. The original pigment is not used for pastel because it is toxic and liable to atmospheric contamination, which may cause it to discolour. If you use Naples yellow pastels they are probably a non-toxic mix. Check the shade card before buying.

Naples yellow. The red's dull, purplish undertone ensures that the colour mixed will be duller than burnt sienna.
10 Burnt umber is simply made paler by adding Naples yellow. The mix may be a trifle warmer but the undertone colour of both burnt umber and the mass tone of Naples yellow are similar. The mix does, however, look very dusty.

11 The acid viridian is warmed and softened by Naples yellow. One can go from light to shadow with this mix in a landscape.
12 It is hard to describe the result of mixing cobalt violet (cobalt magenta) with Naples yellow. The pale, purplish-tan is an unusual colour that would find a place both in portrait and landscape work.

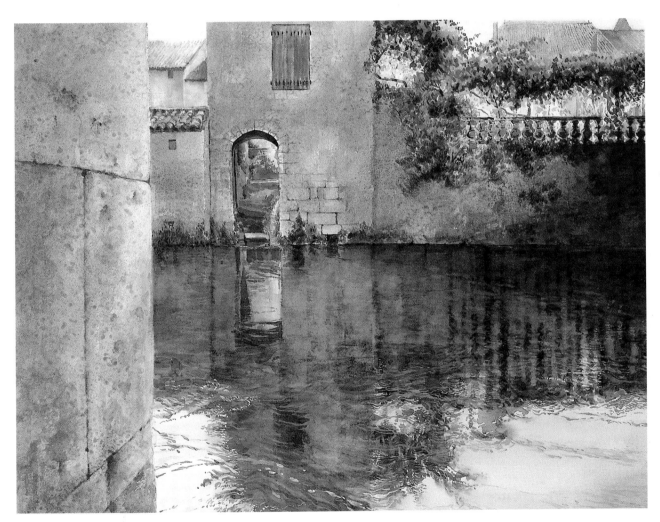

BRANTOME, FRANCE
FRANCES SHEARING
watercolour; 363 x 497mm (14 x 20in)

Naples yellow and aureolin were used as a basic underlayer to this watercolour. Mixes of dioxazine violet and permanent magenta were applied over the stonework and salt was sprinkled on the surface to add texture. Mixtures of aureolin and Prussian blue with touches of Indian yellow were used in the greens and reflections of the arch. The roofs are basically Naples yellow or burnt sienna cooled with permanent magenta and dioxazine violet added for the detailing. The oily green of the water is composed of layers of Naples yellow, Prussian blue, aureolin and alizarin crimson.

INDIAN YELLOW

ORIGINS

Genuine Indian yellow is no longer produced. It was based on a dye extracted from the urine of cattle fed on mango leaves. The colour was first introduced into British artists' palettes at the beginning of the 19th century, but many substitutes of dubious permanence (often based on fugitive aniline colours) were sold as the genuine article. The production of the dye caused the cattle to become ill and in about 1908 the Indian government banned its production. The colour is popular with watercolourists and can now be bought as a "hue" colour. Its lightfastness will vary from manufacturer to manufacturer. Anyone wishing to use a particular brand should carefully check the manufacturer's permanence rating before buying. If no permanence rating is available either on the tube or pan, or in the manufacturer's literature, don't buy it.

COLOUR MIXING CHART

1 The rich orangey yellow becomes more neutral in hue as it is diluted. The wash is very even, of medium strength and grain free.

2 Mixing Indian yellow with white takes the edge off the colour. The more white that is mixed in, the softer and chalkier the colour becomes.

3 The addition of lemon yellow to Indian yellow cools and brightens it to produce a colour which is similar to gamboge.

4 Vermilion hue is a vibrant, transparent red. The orange leanings of Indian yellow combine perfectly with the similar bias of the red, to give a clean, warm orange.

5 The cooler permanent rose, mixed with Indian yellow, gives a duller and sharper orange.

6 The reddish, burnt sienna is warmed to a hot tan by adding Indian yellow. Very autumnal.

Indian Yellow Mixing Chart

7 The best feature of Indian yellow is the wonderful greens that it makes. The soft, sky blue of coeruleum combines with the yellow to give a subtle range of grainy greens that can be varied from olive shades to sharp, light blue-greens.

8 Similar colours, but deeper in tone and grain-free can be made by using phthalocyanine blue. These greens can be varied from cool to warm as required.

9 The grainy French ultramarine never gives bright greens. It has a purplish bias that neutralizes the

PROPERTIES

PERMANENCE: Will vary according to pigment used. For this demonstration I used an Indian yellow, made from a mixture of two pigments – nickel dioxine yellow (PY 153) and benzimidazolone orange (PO62) both of which are ASTM 4302 Class I (excellent lightfastness); Blue wool scale 7–8 (absolutely lightfast).

COLOUR BIAS: Towards orange.

TRANSPARENT/OPAQUE: Transparent.

STAINING: This will depend on the pigment used.

HAZARDOUS: Probably not, but check on manufacturer's colour information.

TINTING STRENGTH: Will vary according to the pigments used.

CHARACTERISTICS: A deep, almost orange transparent yellow, used mainly in watercolour, but found in some oil ranges. Rarely used in other media.

WATERCOLOUR: The deep yellow pales and becomes more neutral as it is diluted. In dilution the colour forms a clean and even wash. It is very transparent and mixes easily with other colours.

OIL: It is good for glazing and mixing, but is not as good when used on its own. Mixes made from synthetic organic pigments will be of medium to high oil absorption and will be average to slow drying, to give a hard and fairly flexible paint film.

OTHER MEDIA: Indian yellow is rarely used in other media.

orange tones of Indian yellow. The greens are therefore more muted and are particularly useful for landscape work.

10 Phthalocyanine green is a powerful, blue green. It is most unnatural when used other than in small touches but, when the edge is knocked off its acidity by the addition of a sunny colour such as Indian yellow, it is transformed into a range of useful greens. By loading more yellow or green, this mix gives a range of colours that take you through a spring, summer or autumn landscape.

11 A soft brown, varying from tan to a neutral purplish colour, will be made from mixing permanent mauve (dioxazine violet) with Indian yellow.

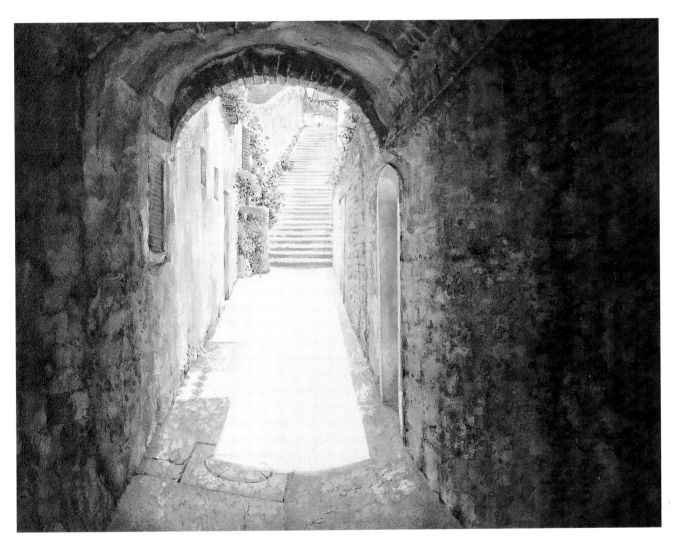

VIA DELLE SCALE, VOLTERRA, TUSCANY
FRANCES SHEARING
watercolour; 355 x 457mm (14 x 18in)

The distant steps and walls are of yellow ochre strengthened and neutralized with permanent mauve. As the walls come towards the arch, Indian yellow has taken over. As they enter the shadowed area, the Indian yellow was mixed with vermilion, burnt sienna and, for the really dark areas, permanent mauve and ultramarine. The shadow on the ground is Naples yellow mixed with permanent mauve.

YELLOW OCHRE – Pigment Yellow 43

ORIGINS

Being an iron rich clay that was literally dug from the ground, the use of yellow ochre is historic. The best quality pigment comes from the Périgord area of France, where it is carefully washed, refined and graded. Depending on source, the colour will vary from a soft, dull yellow to a brownish hue.

The colour is often synthesized – it is then called mars yellow. This pigment is very similar to the original but disperses better in the mediums and, being synthetic, it is easier to maintain colour control over batches.

COLOUR MIXING CHART

1 The colour has a brownish bias and a grainy character.
2 Being opaque, the colour change is negligible when mixed with white.
3 Adding yellow ochre to cadmium yellow creates a sandy colour that positively glows. The smooth cadmium pigment subdues the graininess of the yellow ochre.
4 Adding yellow ochre to cadmium red gives a muted, warm orange, due to the brownish leanings of the ochre.
5 The sharper permanent rose/yellow ochre mix should give a cooler orange and in the more "red-heavy" mixes it does. Permanent rose has good tolerance to both of the other primary colours, so despite its purplish bias, a soft orange results as the amount of yellow increases.
6 The brick-red colour of burnt sienna can be modified to produce a range of rich orangey browns, which in watercolour, will have a grainy character.
7 Grainy coeruleum combines with the equally granular yellow ochre to produce a greyish-green. A strong mix of the two pigments will give a khaki colour.
8 French ultramarine doesn't make bright greens. Adding yellow ochre confirms that the result is going to be muted. The mixed colours are wonderful for landscape – for

Yellow Ochre Mixing Chart

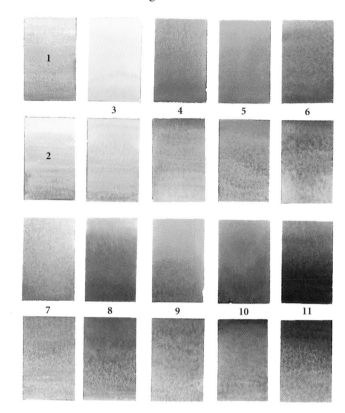

greens in shadow. Even when "blue-heavy", the addition of a touch of ochre takes the rawness out of the colour.
9 Phthalocyanine green is viridian's more powerful and brighter imitator. The green is subdued by the ochre, to produce a range of rich and useful landscape greens.
10 The yellow of the ochre reacts with permanent mauve (dioxazine violet) to produce a muted neutral which, again, is excellent for shadow areas in landscape work.
11 Yellow ochre modifies burnt umber's slightly purplish bias to make a range of delightful warm browns.

PROPERTIES

PERMANENCE: ASTM D4302 Class I (excellent lightfastness); Blue Wool Scale 8 (absolutely lightfast).
COLOUR BIAS: Towards brown.
TRANSPARENT/OPAQUE: Opaque.
STAINING: No.
HAZARDOUS: Not considered hazardous.
TINTING STRENGTH: Fairly low.
CHARACTERISTICS: One of the essential colours in the artist's palette, often included in starter sets. It is a good mixing colour, excellent for warming cooler colours. When used alone in impasto, the colour is undistinguished and can be streaky, making obliteration of under-layers difficult.

WATERCOLOUR: Although an opaque colour, its low tinting strength means that it can be usefully employed in washes. In the watercolourist's palette it is often replaced by the more transparent raw sienna. If washes are not applied in a fluid way there can be a tendency to streakiness and mixed colours have a grainy character.
OIL: Yellow ochre makes a tough, flexible paint film. The oil absorption is medium and the drying speed slow so, unmixed, it would work better in the upper layers of a painting. Its principal value is as a mixing colour rather than in its own right.
OTHER MEDIA: Yellow ochre is compatible with all other media.

HIGH SUMMER, THE MALVERN HILLS
ERIC BOTTOMLEY
oil on canvas; 610 x 915mm (24 x 36in)

Yellow ochre and ultramarine were used for most of the greens in this painting. This was varied by the addition of some burnt sienna here and there. Glazes of coeruleum (cerulean) with white were thinly overlaid in parts to create a feeling of distance. The darker foreground was painted with mixes of burnt sienna, ultramarine and some yellow ochre in the lighter areas. The rocks are yellow ochre with a little burnt sienna, reduced with white.

RAW SIENNA — Originally Pigment Brown 7

ORIGINS

An ancient pigment, raw sienna was originally a native clay containing iron. The best grades – from Tuscany or from the Harz Mountains in Germany – were browner than yellow ochre but more transparent. Nowadays the original pigment, which was dug up, washed and ground finely, is all but obsolete, largely being replaced by a version of the synthetic mars yellow (pigment yellow 42), which often has a red iron oxide (pigment red 101) added, so the colour is close to the original pigment in the manufacturer's colour manual.

COLOUR MIXING CHART

1 The colour is a brownish-ochre, soft and more yellow in thinner applications, browner and streakier when applied densely.
2 Titanium white cools and takes the colour from raw sienna, but makes the colour less streaky.
3 Raw sienna is brightened by adding lemon yellow to give an unusual soft golden colour.
4 The slight opacity of raw sienna reacts with the transparent vermilion hue to give a warm orange that has a dusty character, useful for soft autumn shades and sunsets.
5 The purplish character of alizarin crimson hue argues with the yellow of raw sienna to make a sharp, yet subtle orange.
6 Burnt sienna was originally raw sienna that had been roasted in an oven. They blend easily and naturally to make a lovely soft tan. Again, autumnal scenes would benefit from this grainy mix.
7 The cooler Indian red gives a quieter and less grainy tan, more like rusty metal than autumn leaves. Unlike burnt sienna, Indian red is opaque.

Raw Sienna Mixing Chart

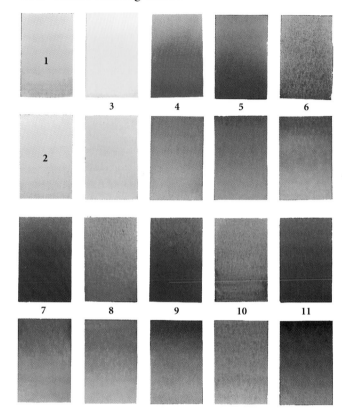

8 A dusty looking soft green results from the mixing of raw sienna and coeruleum. Ideal for landscape grass and, where the blue dominates, grass in shadow.
9 A cool grey-green is made from ultramarine and raw sienna. Again, the darker mix is good in shadow areas.
10 A rounded green results from mixing viridian with raw umber. Viridian brings a grainy character to the mix; this texture can be useful.

PROPERTIES
PERMANENCE: ASTM D4203 Class I (excellent lightfastness); Blue wool scale 8 (absolutely lightfast).
COLOUR BIAS: Brownish.
TRANSPARENT/OPAQUE: Semi-transparent.
STAINING: No.
HAZARDOUS: Not considered hazardous.
TINTING STRENGTH: Medium to low.
CHARACTERISTICS: A useful colour, especially in watercolour, where it is widely used in pale washes, often as an under-wash near the horizon of a blue sky. Applied densely, raw sienna can be streaky, particularly in oil, but adding a little white will correct this.

WATERCOLOUR: Raw sienna is often used in preference to yellow ochre as it is a little more transparent. It is useful for making subtle greens and soft, dusty oranges. Used too densely it takes on an ugly, dead character. A light touch is definitely needed.
OIL: Raw sienna needs a lot of oil to make paint – its oil absorption being up to 200 percent. This means that in time it will darken. In oil, I prefer to use yellow ochre, which seems a little less slippery and streaky. Raw sienna is a medium to fast drying colour, giving a hard and fairly flexible paint film.
OTHER MEDIA: Raw sienna is a superb pigment in any medium.

11 Permanent mauve (dioxazine violet) – almost the complementary colour of the yellowish raw sienna – mixes to give a dark, yet rounded purplish-brown that will find many uses in landscape work, particularly in shadow areas. Its transparency ensures that it will blend well with other colours.

MUSIC AT PHILIPPS HOUSE
TONY PAUL
watercolour; 560 x 380mm (22 x 15in)

Raw sienna was used as a base colour for much of this painting, particularly for the walls and floor. The warm tan of the piano top is a mix of Indian red and coeruleum into which raw sienna was dropped, wet-in-wet, over most of it. Indian red and coeruleum was used for the cooler sides of the piano. These colours were also used wet-in-wet in the floor. A thin wash of coeruleum and Indian red was drawn across parts of the background wall and curtain to darken their tone. The strong darks are Indian red and ultramarine. A tiny amount of vermilion hue was added to the right-hand side of the girl's face to warm it.

GAMBOGE – Natural Yellow 24

ORIGINS

This natural yellow is not really a pigment at all, but a natural gum produced from trees in Thailand. It came into use in the Middle Ages and continued to be used up until Victorian times, when it was largely superseded by the newly discovered, and more reliable, cobalt yellow (aureolin). In most manufacturers' ranges, gamboge has been replaced by "hues" which have the characteristics of the original pigment, but are less expensive and often more lightfast. True gamboge is still made by a few manufacturers for watercolourists who like traditional colours, but tradition aside, there is little point in using any colour which is destined to fade.

COLOUR MIXING CHART

I used the lightfast gamboge hue for the colour mixes in this session. I would not consider buying or using the genuine pigment.

1 You can see that where the colour is applied densely it is quite orangey, yet where it is thinner the yellow, although still leaning to orange, is more neutral. The colour works well into an evenly graduated wash.

2 Mixing white with the pigment destroys its transparency and it also loses much of its zing. The colour is almost ochre in comparison, with a dusty look.

3 Cadmium red already leans towards orange so we get harmony when gamboge hue is added – a clear bright orange is created.

4 Alizarin crimson's purplish leanings argue a little against gamboge hue's sunny yellow to produce a slightly subdued orange, a touch more acidic than the last mix.

5 The granular burnt sienna makes a lovely subdued but hot orange when mixed with gamboge hue. Colours such as this are wonderful for autumnal landscapes.

6 Another autumn landscape colour; duller but equally useful is burnt umber and gamboge hue. Like burnt sienna the mixed colour has a granular quality.

7 Coeruleum also has a granular quality that imposes

Gamboge Mixing Chart

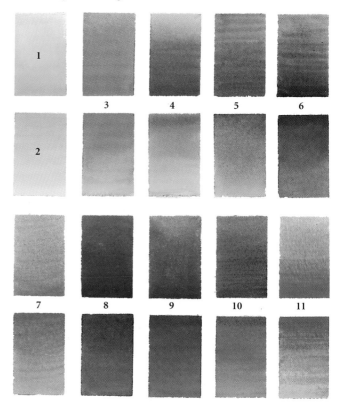

itself on this mix. At its densest mix, coeruleum is not a dark colour and will not give dark greens, but it does make pleasant and useful greens. Due to the orangey bias of gamboge hue, any mixed green will never be astringent but it will make a variety of soft shades.

8 The orange bias of gamboge hue argues with the purple leanings of French ultramarine to produce an olive green. Very useful for landscape work and quite a powerful colour.

9 A green of similar strength but a little sharper can be made from phthalocyanine blue. This is a similar colour to that produced by coeruleum, but can be made darker. The grainy effect of coeruleum is, however, missing.

PROPERTIES (Original Pigment)
PERMANENCE: ASTM D4302. Not tested, probably because of its impermanence and impending obsolescence.
COLOUR BIAS: Towards orange.
TRANSPARENT/OPAQUE: Transparent.
STAINING: Yes.
HAZARDOUS: The modern colour is not considered hazardous. Older colours, produced since 1978, will have a hazard warning symbol if they contain any hazardous substances. For a tube or pan that pre-dates 1978, it would be wise to treat it as having a hazardous element.

TINTING STRENGTH: Medium.
CHARACTERISTICS: A bright yellow which, when applied fairly densely, has a distinct orangey colour. This effect is reduced when the wash is thin; a fairly neutral yellow results. The characteristics of the original pigment have been imitated by most manufacturers and are sold as "hues".
WATERCOLOUR: The sunny quality of the colour and its transparency make it useful in watercolour painting. The more permanent "hue" equivalents should be used for quality work.
OTHER MEDIA: Gamboge is not used in other media.

10 The sharpest green is made from combining gamboge hue and phthalocyanine green. The more yellow that is added, the rounder the colour becomes; the more green that is mixed in, the sharper it is.

11 The reddish cobalt violet (cobalt magenta) combines with gamboge hue to make an unusual soft brown which could be used in landscape work. Although opaque, the violet's weakness makes it appear transparent.

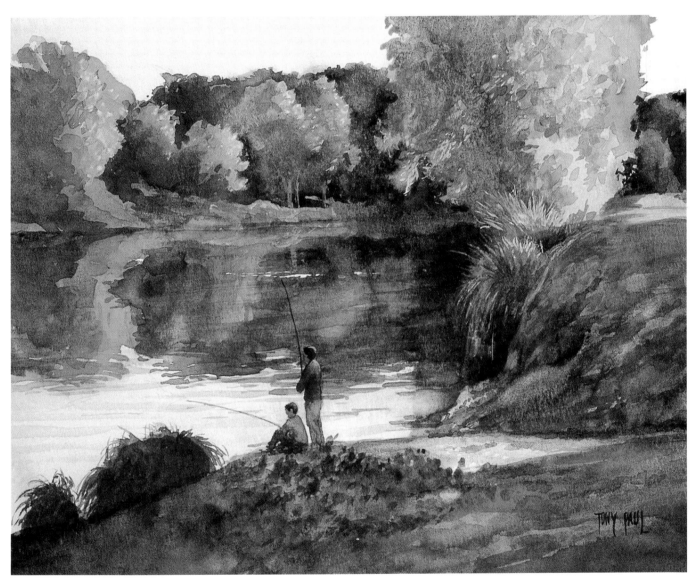

THE CHER, LOIRE VALLEY – EARLY EVENING
TONY PAUL
watercolour; 280 x 340mm (11 x 13in)

The light area of the right-hand tree was washed in with pure gamboge hue. Into this I dropped cobalt magenta and cobalt green to create the cooler shadow side of the tree. Gamboge hue and ultramarine, with cobalt magenta dropped in to warm it, was used for the trees on the distant bank and their reflections. The sky was washed in with raw sienna, while the shaded bank and foreground are various blends of gamboge hue, cobalt green, cobalt magenta, ultramarine and phthalo green.

AUREOLIN — Pigment Yellow 40

ORIGINS

Aureolin, or cobalt yellow, was first introduced into the artists' palette in about 1860. Applied thinly it is bright, slightly greenish-yellow but when squeezed from the tube, it is an ochre colour. Some artists like its subtlety, but like all cobalt colours, it is expensive and fairly weak in tinting power so it will take a fair amount of colour to make a reasonably dense wash.

COLOUR MIXING CHART

1 See how ochre in colour aureolin is when applied thickly. As it thins, a transparent, subtle greenish-yellow shade emerges.

2 Mixed with white it becomes slightly duller and chalky.

3 When aureolin (a), is compared to lemon yellow (b), or cadmium yellow (c), it appears quite dull, but has a quiet personality.

4 Its greenish bias subdues the fire of cadmium red to a soft orange – a good autumnal colour.

5 The sharp, purplish permanent rose combines with aureolin to give an astringent, soft orange.

6 Burnt sienna is softened to produce a warm tan with aureolin.

7 As this aureolin leans towards green you might expect clean greens, but this is not the case. Probably because the mass tone is a greeny-brown, the greens that result have a useful subtlety, ideal for landscape work. Coeruleum and aureolin make a rounded, grainy green – firmer and less delicate than the usual coeruleum-based greens.

8 The aureolin/French ultramarine mix is rather olive. The blue all but neutralizes to grey-green. Very useful for shaded foliage.

9 Phthalocyanine blue (monestial/phthalo) usually gives clear greens, but even its power is subdued by the yellow. Still, it is a useful landscape green.

10 The brightest green in this demonstration is an aureolin/viridian mix. Aureolin cannot subdue the sharp character of the green pigment.

11 A useful ochre brown is obtained from permanent mauve (dioxazine violet) and aureolin. This would be transparent and may successfully be substituted for some of the more opaque red-browns, such as light red, Venetian red, Indian red or mars violet.

Aureolin Mixing Chart

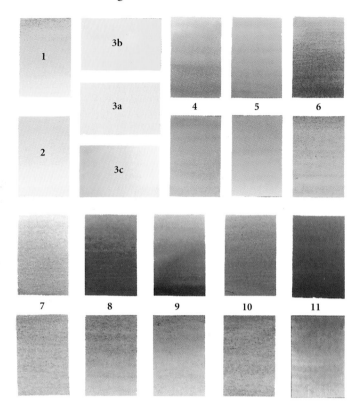

PROPERTIES

PERMANENCE: ASTM 4302 Class II (excellent lightfastness); Blue wool scale 7 (absolutely lightfast).

COLOUR BIAS: It varies – sometimes orangey, sometimes greenish. The brand I use tends towards green.

TRANSPARENT/OPAQUE: Transparent when applied thinly.

STAINING: No.

HAZARDOUS: The modern colour is not considered hazardous. Older colours, produced since 1978, will have a hazard warning symbol if they contain any hazardous substances. For a tube or pan that pre-dates 1978, it would be wise to treat it as having a hazardous element.

TINTING STRENGTH: Medium to low.

CHARACTERISTICS: A subtle yellow, best in transparent glazes or washes. Mixes tend to be subdued.

WATERCOLOUR: Transparent and ideal for watercolour, drying flat and even. If the resulting painting is displayed in damp conditions or in strong, direct sun, the aureolin may turn ochre in colour.

OIL: Ochre and undistinguished in mass, it is best reserved for transparent glazes. It has a medium oil absorption and dries quickly to give a hard paint film.

OTHER MEDIA: Aureolin is rarely used in other media.

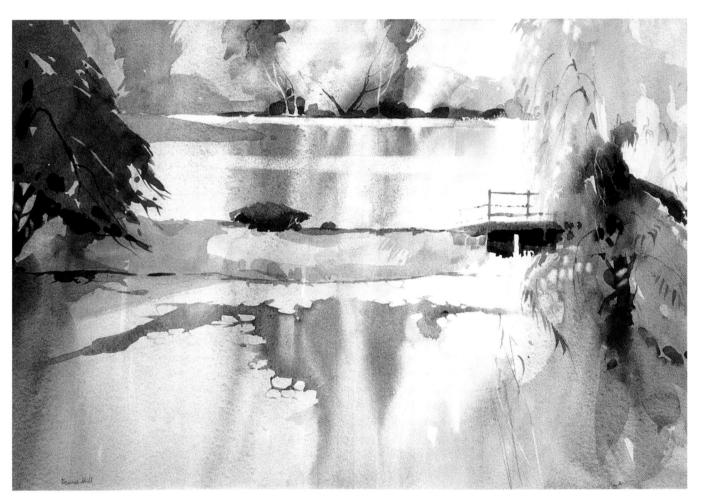

THE MILL POND
DENNIS HILL
watercolour; 330 x 510mm (13 x 20in)

Only four colours were used in this painting: aureolin, permanent mauve (dioxazine violet), ultramarine and a dash of cadmium yellow. The greens were made of aureolin with ultramarine. This was varied and warmed by dropping in the violet, wet-in-wet. The tans were made by mixing the violet with aureolin, while darks were mixed from the violet and ultramarine, with enough aureolin to reduce the colour's bluish character. A dash of the warmer cadmium yellow was dropped into the greeny-yellow area on the lower right.

CADMIUM ORANGE – Pigment Orange 20

ORIGINS

Discovered in 1817, it was in general use in 1846 but, due to the scarcity of the metal, it was some years before the colour was widely adopted. It replaces the more toxic and less lightfast chrome orange.

COLOUR MIXING CHART

1 The powerful cadmium orange gives a clear, clean orange. If mixing it with less potent colours, add the orange in small amounts to avoid overpowering the other colour. In watercolour the washes are flat and even.
2 Mixing white with cadmium orange takes the edge off its clarity, making it slightly chalky.
3 The greenish quality of lemon yellow reacts with the red in the colour, dulling it to give a soft orange.
4 If you want a hot, ochre colour, mixing raw sienna with cadmium orange will create one. The grainy quality of the earth colour adds interest to the mix.
5 Cadmium orange is made from the chemicals that make both cadmium yellow and cadmium red. Adding cadmium red makes the orange hotter. Vermilion shades are easily achieved and, as there are no colour bias conflicts, the colour is both powerful and pure.
6 Permanent rose (quinacridone) is one of the new breed of excellent synthetic organic pigments and although it has a positive leaning to purple – so much so that it is classed as a violet pigment (pv19) – it nevertheless has a good tolerance to the orange side of the spectrum and gives a sharper, but equally clean, hot orange.
7 The purplish undertone of Indian red provides a cool note to the mix with cadmium orange. The orange warms the colour and gives it an under-glow, even when the red predominates.

Cadmium Orange Mixing Chart

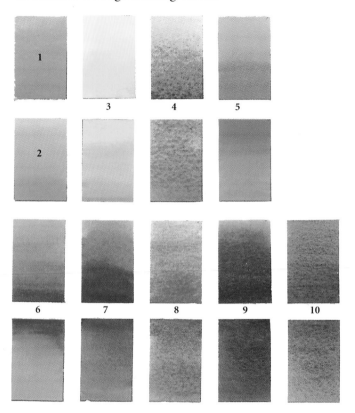

8 Mixing complementary colours will give a neutral colour. The greenish coeruleum combines with the yellow in the orange to create a wonderful dull grey-green. Where the orange dominates, the green is quite brownish. An excellent green for landscape work. The colour has a kind of under-glow.

PROPERTIES

PERMANENCE: ASTM 4302 Class I (excellent lightfastness); Blue wool scale 7 (absolutely lightfast).
COLOUR BIAS: Varies from yellowish to reddish, depending on the manufacturer.
TRANSPARENT/OPAQUE: Opaque.
STAINING: Slightly
HAZARDOUS: The modern colour is not considered hazardous. Older colours, produced since 1978, will have a hazard warning symbol if they contain any hazardous substances. For a tube or pan that pre-dates 1978, it would be wise to treat it as having a hazardous element.
TINTING STRENGTH: High.
CHARACTERISTICS: A top quality colour, the hue of which will vary from manufacturer to manufacturer. It is an expensive pigment, which means that it may be substituted

by a "hue" colour made from cheaper pigments. Cadmium colours will fade if the resulting painting is kept in a damp atmosphere, but damp would also have a devastating effect on the rest of the painting.
WATERCOLOUR: Cadmium orange is opaque, so not ideal for creating transparent effects. Thinned down to make it seem transparent it will still appear as a superimposed film, rather than blending to make a third colour. If opacity is not a problem, then it is a superb colour.
OIL: All cadmium colours work well in oil and give a rich buttery paint that blends and mixes easily. Cadmium orange has a slow drying speed and high oil absorption, so would be better used, unmixed, in the upper layers of a painting. It dries to give a hard and fairly flexible paint film.
OTHER MEDIA: Can be used in all media except in pastel, where the original pigment will be replaced by a hue colour.

9 An optically equal mix of French ultramarine and cadmium orange will give an almost neutral grey which, if stronger on the blue side, will give a dull blue-grey. But, if the emphasis is on the orange, an unusual dull brown is created.

10 Viridian and cadmium orange combine to create a warm and fairly dull green. In watercolour, the pigments separate as they dry to create interesting textural effects. Another excellent mix for landscape work.

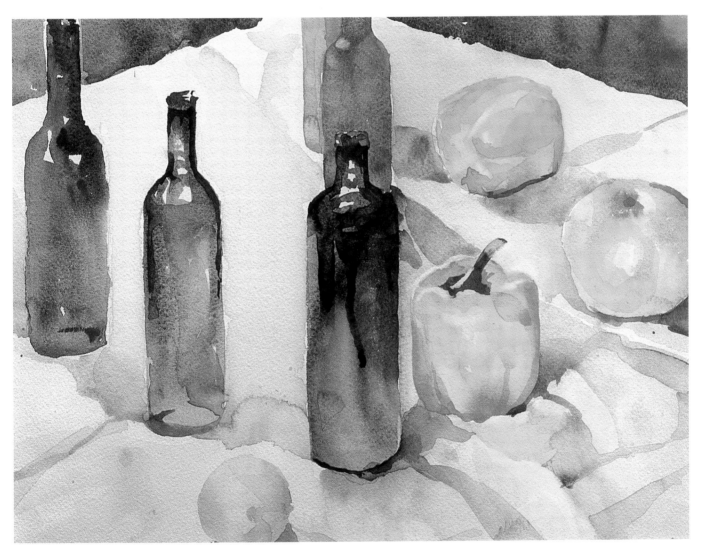

STILL LIFE WITH BOTTLES
DENNIS HILL
watercolour; 290 x 420mm (11 x 17in)

Cadmium orange was used throughout the painting in wet-in-wet applications. Cadmium yellow and rose madder were added for the peppers, while the fruit on the right also had a touch of viridian dropped into the wet wash. The central and far left bottles, the background and the shadows were painted using mixes of cadmium orange, ultramarine and rose madder all flooded in, wet-in-wet, while the green bottle was given an under-layer of orange and ultramarine, over which was painted variations of viridian and cadmium yellow.

REDS

RIGHT Sketch for Tea at Philipps House; *watercolour;
by Tony Paul. Mixes of raw sienna, Indian red, burnt sienna,
ultramarine, permanent rose and burnt umber were used in
this painting.*

ALIZARIN CRIMSON — Pigment Red 83

ORIGINS

This rich crimson was introduced in Germany in 1868 and became a mainstay of the artist's palette, but its permanence is dubious and in pale washes or tints with white, fading is likely.

COLOUR MIXING CHART

1 The pigment in a transparent wash. The colour is strong, vibrant and makes a good, even wash.
2 When white is added, alizarin crimson's transparency is destroyed. Paler tints are chalky looking, and the deeper red-white mixes lose some of the power of the raw pigment. The more white that is added the more the colour is likely to fade.
3 The greenish accent of lemon yellow fights with the red, and the purplish bias of the red opposes the yellow to produce a fairly muted orange.
4 The orangey gamboge hue makes a clearer orange, but it is still muted.
5 The yellow-brown of raw sienna mixes with alizarin to produce a burnt sienna hue. A useful landscape colour.
6 Cadmium red light and alizarin make a rich red: neutral but with plenty of character.

Alizarin Crimson Mixing Chart

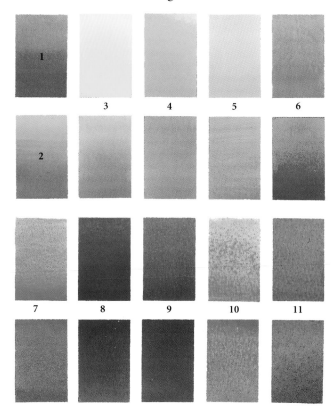

PROPERTIES
PERMANENCE: ASTM D4302 Class III (fair lightfastness); Blue wool scale 6–7, in tint Blue wool scale 5 – not sufficiently lightfast.
COLOUR BIAS: Towards purple.
TRANSPARENT/OPAQUE: Transparent.
STAINING: Strongly.
HAZARDOUS: Not considered hazardous.
TINTING STRENGTH: High.
CHARACTERISTICS: Inexpensive and powerful, it is best used in glazes where its richness can be exploited. Unmixed in thick applications, it becomes dark and dull. Many manufacturers now offer a more permanent alizarin crimson hue as an alternative to the original pigment.
WATERCOLOUR: Alizarin crimson handles well in watercolour, with a good wash quality. The colour delicacy in pale applications is delightful.
OIL: The pigment is slightly more lightfast than in watercolour. This is negated by the extremely high oil absorption which can make it yellow and wrinkle if applied thickly. Unless mixed with lean colours it should be used in the upper layers of a painting.
OTHER MEDIA: Alizarin crimson is not compatible with acrylic and is usually substituted by one of the napthol reds, which are often more lightfast. It can be used in all other media.

7 Alizarin crimson makes lovely purple-violets. The first of these is with coeruleum blue. The greenish leanings of the blue softens the purple – a good colour for distant landscape.
8 French ultramarine, like alizarin, leans towards violet and makes a lovely rich purple.
9 Phthalo blue (monestial/Winsor blue) has a green bias which softens the mix into a rather useful dark and dull violet.
10 Cobalt violet (cobalt magenta) is a delicate soft purple. It achieves an unusual warm hue when alizarin is added.
11 Finally, the complementary colours mixed – Viridian's bluish bias has sympathy with the character of alizarin and the mix is cool and neutralized. When pale, this is good for distant landscape, but make sure that a neutral colour is made. Both colours are powerful and too strong a leaning to either colour would kill the effect of distance. In gouache, oils or acrylic, white should be added to the mix.

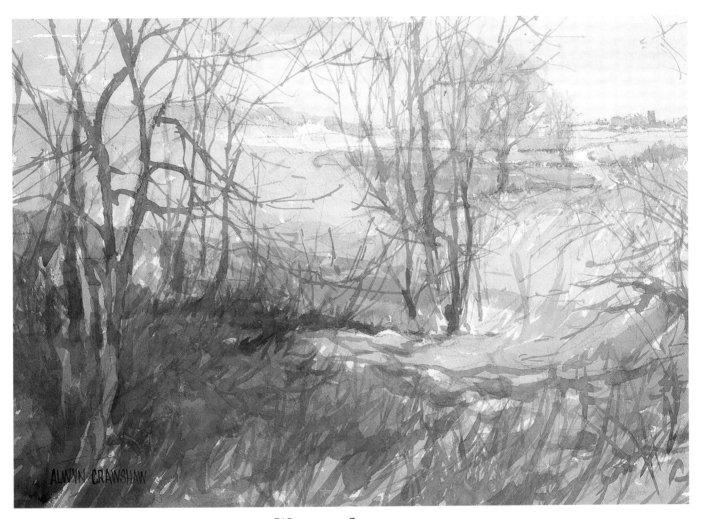

WATERY SUNLIGHT
ALWYN CRAWSHAW
acrylic; 380 x 508mm (15 x 20in)

Although acrylic, this painting was worked in a fluid watercolour technique. The sky was washed in with ultramarine and a little alizarin crimson, with the background a mix of these colours with raw sienna and bright green. All colours were heavily diluted.

The foreground was worked using the same colours, but stronger, with some raw umber. Although more dense, the foreground colours were still applied very wet, giving a sense of recession to the cooler and paler ones in the background beyond the trees.

CADMIUM RED – Pigment Red 108

ORIGINS

Introduced in Germany in 1907, its use was taken up by British manufacturers soon after. Available in a variety of shades, ranging from oranges to deep red. The cadmium pigments were the first stable, bright red colours, perfectly replacing the chrome reds that had been in use since 1797. It will only be found in artists' quality ranges because it is expensive. In student ranges the cadmium pigment is substituted by a "hue" colour made from cheaper pigments.

COLOUR MIXING CHART

1 A range of pigments can be made from the cadmium raw material: (a) is cadmium scarlet, (b) is cadmium red and (c) is cadmium red deep. The colours will vary according to the manufacturer.
2 The colour used for this chart veers towards scarlet and gives an even wash.
3 When mixed with white the colour changes little, but in paler tints the mixed colour can appear chalky.
4 The perfect companion for cadmium red is cadmium yellow. Both lean towards orange, so when mixed make a good, clean opaque orange.
5 Raw sienna is a granulating colour, so in watercolour any mix will also have a grainy quality. This mix gives a

Cadmium Red Mixing Chart

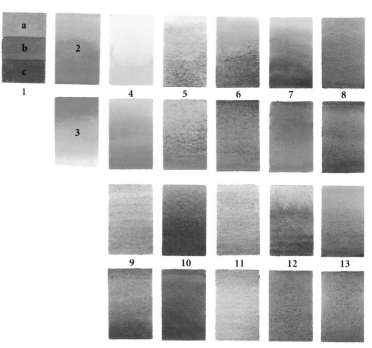

PROPERTIES

PERMANENCE: ASTM 4302 Class I (excellent lightfastness); Blue wool scale 7 (absolutely lightfast).
COLOUR BIAS: Towards orange.
TRANSPARENT/OPAQUE: Opaque.
STAINING: Slightly staining.
HAZARDOUS: The modern colour is not considered hazardous. Older colours, produced since 1978, will have a hazard warning symbol if they contain any hazardous substances. For a tube or pan that pre-dates 1978, it would be wise to treat it as having a hazardous element.
TINTING STRENGTH: High.
CHARACTERISTICS: A powerful bright red that is best in oil. Both cadmium red and cadmium scarlet are clean and good mixers, but the cadmium red deep is muddy in mixes.
WATERCOLOUR: Cadmium red is commonly used by watercolourists despite its opacity. It can give either finely dispersed or grainy washes depending on the manufacturer.
OIL: It has a medium oil absorption and dries slowly to produce a hard and flexible paint film. Its slow-drying nature makes it more suited to the upper layers of a painting.
OTHER MEDIA: Can be used in all media except in pastel, where the original pigment will be replaced by a hue colour.

very muted but glowing deep orange that is useful in still life, landscape and portrait.
6 Adding burnt sienna to cadmium red extends the range of the previous mix to produce a hot, rusty brown.
7 The cool purply undertone of Indian red makes the mixed colour sharper than the last mix, but as the pigment does not granulate the resulting wash is smoother.
8 Cobalt blue is the most neutral blue in the artist's palette. It is also a fairly weak pigment, so always add cadmium red in small amounts. The resulting dull purplish colour would be very useful for any subject.
9 Coeruleum's green bias argues with the orangey cadmium red to produce a greyish middle colour. In watercolour the opaque blue's graininess remains in the mix and the red generally remains evenly dispersed, creating a mottled effect.
10 French ultramarine has a purplish bias. This mismatches cadmium red's orange bias to give a restrained dark purple which has a glow to it. A most useful mix for any subject.
11 Cobalt violet (cobalt magenta) is a very weak but rather beautiful grainy colour. Adding cadmium red gives the mix a rather unusual soft and subtle pink.
12 Burnt umber is a dullish brown. Adding a touch of cadmium red will give it a hot under-glow.
13 Phthalocyanine green – a rather unnatural green – will create a range of useful neutral colours when mixed with cadmium red (they are opposites in the colour wheel). A good mix for winter landscapes.

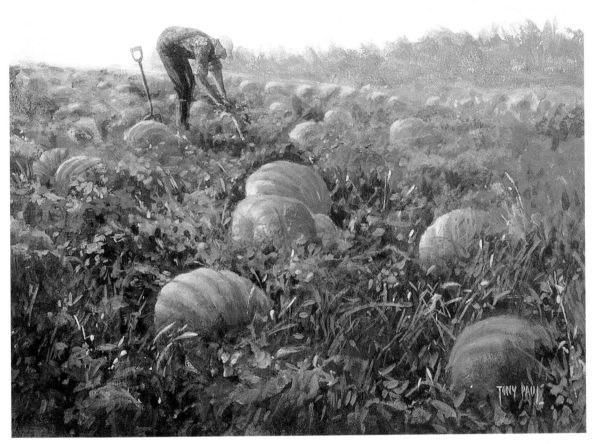

PUMPKIN FIELD, DELMARVA PENINSULA, MARYLAND
TONY PAUL
acrylic; 280 x 300mm, (11 x 12in)

The sky was scumbled in a mix of ultramarine broken with a little crimson and lightened with white. The under-layer for the ground was scrubbed in with a broken mix of burnt umber and cadmium red. In parts, crimson or a touch of ultramarine was added instead of the cadmium red. The distant trees were created from crimson blended with phthalo green plus white. The greens were made from ultramarine with permanent yellow or cadmium yellow deep, with cadmium red mixed in here and there or applied as a glaze. The pumpkins are cadmium yellow deep and cadmium red, lightened with white and darkened with burnt umber.

PERMANENT ROSE (Quinacridone) — Pigment Violet 19

ORIGINS

Discovered in 1958, quinacridone was introduced into the artist's palette in the early 1960s. It was used to replace, in artists' quality paints, the colour known as permanent rose. Quinacridone is a first-rate synthetic, organic colour which can be used in all media.

COLOUR MIXING CHART

Permanent Rose Mixing Chart

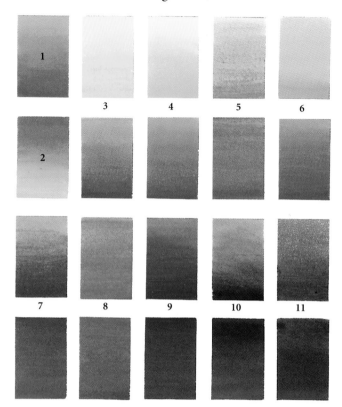

1 The colour is not dissimilar to alizarin when used in strength but is slightly paler in mass tone. When the colour is thinned in a glaze or wash its delicacy is revealed.

2 Adding white dulls the colour slightly. Pale tints can appear chalky.

3 The greenish bias of lemon yellow gives a sharp edge to a mixed orange. The colour is clean despite the purple leanings of the quinacridone pigment.

4 From using cadmium yellow in a mix, a variety of strong, clean oranges result. A balanced mix of the two colours will give a brilliant scarlet.

5 The brownish character of yellow ochre dulls the radiance of permanent rose to give a granular muted orange. The opacity of the ochre gives a slightly dusty character to the colour.

6 As cadmium orange is between cadmium red and yellow, adding permanent rose gives a deeper version of the cadmium yellow mix. A very hot colour.

7 Permanent rose added to burnt sienna gives the rich, red brown an undertone of even greater heat. Like the yellow ochre mix, this would be ideal for autumnal landscapes.

8 As might be expected, the purple bias of permanent rose will ensure that good purples result when mixed with blue. Unlike permanent rose, coeruleum is a grainy and heavy pigment, and in watercolour washes the pigments can separate to give mottled effects. The purple is muted, due to the greenish bias of coeruleum and the opacity of the blue gives the mixed colour a soft bloom. This is one of my favourite mixed colours.

9 French ultramarine's transparency and purple leanings complement perfectly those of permanent rose, to give a rich and vibrant purple or violet. In watercolour the wash will tend to be granular, due to the flocculation of

PROPERTIES

PERMANENCE: ASTM D4302 Class 1 (excellent lightfastness); Blue wool scale 8 (absolutely lightfast).
COLOUR BIAS: Towards violet.
TRANSPARENT/OPAQUE: Transparent.
STAINING: Strongly staining.
HAZARDOUS: Not considered hazardous.
TINTING STRENGTH: Medium.
CHARACTERISTICS: A delicate yet rich rose red, much loved by flower painters. Although it veers towards purple, it has a wide tolerance to the yellow side of the spectrum, giving excellent oranges and scarlets. In fact, it is very difficult to make a mucky colour in a binary mix, so pure is its hue. It has about half the power of alizarin crimson.

In mixes it would be wise to add more powerful colours by degrees to permanent rose, so that it is not overpowered.
WATERCOLOUR: An excellent colour giving absolutely transparent, evenly gradated washes. It is a good substitute, particularly in pale washes, for alizarin crimson, which nowadays is not considered permanent enough for quality work.
OIL: As it is transparent it is best used in glazes or mixed with a little white to give it opacity. Its high oil absorption and medium to slow drying speed mean that it would be better used in the upper layers of a painting. The colour dries to give a hard and reasonably flexible paint film.
OTHER MEDIA: Permanent rose is excellent for use in all media.

the ultramarine pigment. This is an excellent mix to give a lightfast range of purples.

10 The rich brown of burnt umber is given an interesting, hot purplish undertone by the addition of permanent rose. A mix of immense character.

11 The unnatural bluish phthalocyanine green combined with permanent rose produces a very subtle yet brooding deep grey in a neutral mix. Adding white to the mix would create a versatile range of unusual transparent and subtle greys.

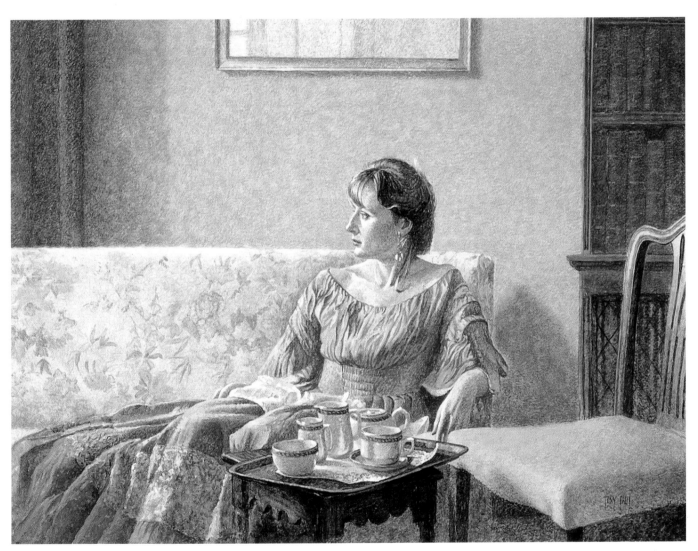

TEA AT PHILIPPS HOUSE
TONY PAUL
egg tempera; 510 x 610mm (20 x 24in)

The basic colour for the dress is permanent rose. This was modified by tinting the colour to a pale pink with white and toning it down with coeruleum and ultramarine. To create a little more warmth in certain areas, cadmium red was added. Similar mixes, but with a little burnt sienna broken in, were used for the curtains. The greenish wall was yellow ochre, pale viridian, pale burnt sienna and coeruleum, all applied in broken touches to blend in the eye. The dark of the bookcase was made from ultramarine and burnt umber.

VERMILION — Pigment Red 106

ORIGINS

Cinnabar was the earliest bright red made. First used in Egypt in about 1500 BC, it was made by crushing and grinding the hard rock. Very expensive to produce, it was traded extensively with Mediterranean countries.
The colour was synthesized in China sometime later and the technique brought to Europe by Arab traders. An 8th-century recipe was written in an alchemical treatise called the *Mappae Clavicula*.

Made from sulphur and mercury, vermilion was a brighter colour than cinnabar, but was still expensive. Its colour was so prized that painting commissions often specified the amounts of both vermilion and ultramarine to be used. Nowadays it is almost obsolete. It has the reputation of discolouring in water-based media yet is reliable in oil. Due to difficulties in obtaining reliable supplies manufacturers have replaced it with hue colours. In some student ranges impermanent pigments have been used to provide the hue colour, so beware! For the colour mixes I used genuine vermilion watercolour.

COLOUR MIXING CHART

1 The dense, vibrant quality of vermilion can clearly be seen. When it is diluted it becomes quite orangey in colour and a little granular.
2 Adding white to vermilion gives it a distinctly chalky character.
3 The greenish bias of lemon yellow gives a slightly cool, soft orange.
4 Cadmium yellow already leans towards orange, so when vermilion is mixed in, a full hot orange is the result.
5 The greenish brown character of raw sienna

Vermilion Mixing Chart

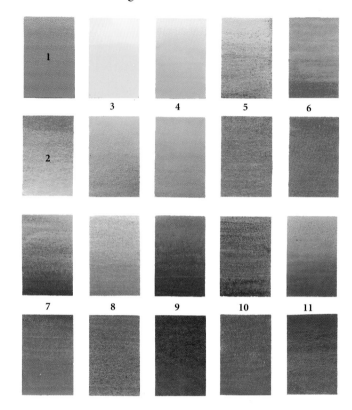

reduces vermilion's vibrancy to produce a subtle, hot, light brown.
6 A subtle full red is made by mixing vermilion with permanent rose. The mix benefits from rose's delicacy and vermilion's richness.
7 Burnt sienna glows when vermilion is added to create lovely autumnal colours.

PROPERTIES (Original Pigment)
PERMANENCE: ASTM 4302 Oils Class I (excellent lightfastness); Blue wool scale 7 – 8 (absolutely lightfast). Water-based media Class III (not sufficiently lightfast). Atmospheric pollutants can sometimes turn the colour almost black.
COLOUR BIAS: Towards orange.
TRANSPARENT/OPAQUE: Moderately opaque.
STAINING: No.
HAZARDOUS: The original pigment – mercuric sulphide – if soluble, was poisonous. Its use was banned in the mid-1990s. If you have an old tube or pan, take care. Modern hue colours are normally non-hazardous.

TINTING STRENGTH: Medium.
CHARACTERISTICS: A heavy pigment – it sometimes separates from the binder in the tube. Vermilion is a bright red that can vary from almost an orange to a fairly neutral full red.
WATERCOLOUR: The real pigment is obsolete. Hue colours will now be used. These will be more reliable and may be transparent.
OIL: Despite genuine vermilion's long pedigree, modern pigments such as the cadmium reds are more stable.
OTHER MEDIA: The genuine pigment is best avoided altogether. Substitute hue colours will be used in all modern media.

8 Coeruleum, when mixed with vermilion, gives an attractive range of purplish-greys, ideal for use in landscape work.

9 I was surprised at how good a purple I achieved mixing French ultramarine with vermilion. It does have a dusty quality, but how it glows.

10 Raw umber and vermilion produce a rather muted tertiary looking colour. It could be seen as a darker extension of the range of colours mixed for no. 5 above.

11 Oxide of chromium and vermilion give a range of brownish to greenish colours, all muted and ideal for European landscape.

CHICKENS IN THE YARD
FRANCES SHEARING
watercolour; 150 x 100mm (6 x 4in)

Vermilion was used undiluted for the combs of the chickens and mixed with burnt sienna or Naples yellow for the lighter parts of their feathers. The shadow areas were overlaid with permanent magenta. Darker areas of the ground are of vermilion and cobalt blue, while the straw was variegated with mixes involving vermilion, aureolin, ultramarine and Naples yellow.

PERMANENT MAGENTA – Pigment Violet 19

ORIGINS

In artists' colour terms, the word "permanent" is one that cannot necessarily be taken as read. The colour magenta was traditionally a fugitive colour, usually being made from impermanent lake colours based on synthetic dyes. In this case the permanent label is probably accurate, as most permanent magentas are, nowadays, made from the wonderful range of quinacridone pigments. If in any doubt, check the manufacturer's lightfastness rating.

Earlier we looked at permanent rose (see page 72), which is based on the red shade of quinacridone PV19, and for permanent magenta sometimes the blue shade is used. On other occasions quinacridone PV42 or quinacridone PR122 is used. All of these are good pigments. For the chart I used permanent magenta made from blue shade PV19. The specifications written below all relate to this pigment.

Magentas – basically reddish-purples – are particularly valued by flower painters. They have a purity of hue that is often difficult to obtain using colours mixed from reds and blues. They are clear and vary from bright to dull depending on manufacturer and pigment source. Generally speaking, the magentas made from PV42 and PR122 are brighter and redder than the blue shade PV19.

COLOUR MIXING CHART

1 Quite rich when applied densely, permanent magenta dulls considerably when diluted into a thin wash.
2 Adding white gouache subdues the red element of the magenta and emphasizes the blue.
3 Cadmium yellow pale has a slight leaning towards green. The red element of magenta is partially neutralized by this and, of course, as purple and yellow are opposites in the colour wheel, we must expect that a mix of these two colours will be fairly neutral. A useful colour in landscape work.

Permanent Magenta Mixing Chart

4 The sunnier hue of cadmium yellow deep is more sympathetic to the red element of the magenta. The resulting mix, although still subdued, is warmer.
5 Orangey cadmium red is deepened and made more neutral by adding permanent magenta.
6 The tone of permanent rose, even when applied thickly, is not dark. Adding permanent magenta, which is just a bluer and darker version of the same pigment, extends its tonal range.
7 Adding magenta to burnt sienna reduces its warm orange bias to produce an unusual, but excellent, landscape colour.

PROPERTIES

PERMANENCE: ASTM 4203 Class I (excellent lightfastness); Blue wool scale 8 (absolutely lightfast).
COLOUR BIAS: Towards blue.
TRANSPARENT/OPAQUE: Transparent.
STAINING: Strongly staining.
HAZARDOUS: Not considered hazardous.
TINTING STRENGTH: Medium.
CHARACTERISTICS: A delightfully pure, if slightly dull magenta, which will be of greatest use to flower painters who may use it for shadow colours in brighter red blooms. The fact that it is a natural reddish-purple, rather than one mixed from blue and red, means that adding other colours will result in cleaner mixed colours.
WATERCOLOUR: Its transparency makes it excellent for watercolour. It has a fine grainy quality that is enhanced when mixed with other granular pigments.
OIL: As it is transparent it is best used in glazes, or mixed with a little white to give it opacity. Its medium oil absorption and medium to slow drying speed mean that it would be better employed in the upper layers of a painting. The colour dries to give a hard and fairly flexible paint film.
OTHER MEDIA: The quinacridone pigment performs well in any media.

8 Greenish coeruleum blue and magenta mix to give a quiet grainy purple, ideal for distant landscape.
9 Still a little on the dull side, French ultramarine and magenta make a fuller, subtle range of dark violets.

10 The heat of the colour is increased when burnt umber and magenta are mixed.
11 The magenta and viridian completely neutralize one another, to create a grainy and unusual greyish colour.

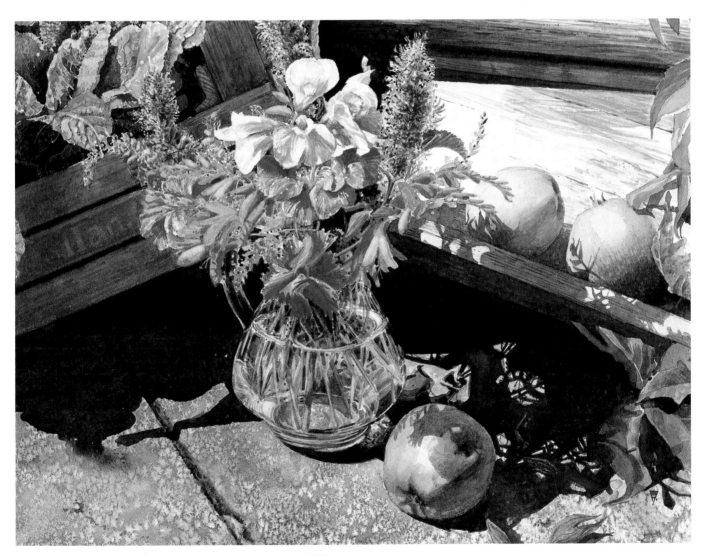

WINDFALLS
FRANCES SHEARING
watercolour; 178 x 254mm (7 x 10in)

The pale pink flowers are largely permanent magenta with tiny touches of vermilion dropped in wet-in-wet here and there. Vermilion predominates in the larger, red flowers with the orangey ones being made from gamboge, vermilion and a little alizarin in the shadows. The apples and leaves are aureolin and ultramarine warmed with a dash of gamboge and vermilion. The darks are ultramarine with a touch of vermilion and the wood a mix of permanent magenta and burnt umber. The wet-in-wet mixes for the paving are the mixed green with raw sienna. Salt was dropped into the wet paint to add texture to the slabs. When the wash was dry it was brushed off.

BLUES AND VIOLETS

RIGHT Sunset, Poole Harbour; *watercolour; by Tony Paul.*
Painted in a sequence of transparent washes – orange, permanent
rose and ultramarine – the darks were overlaid using a mix of
ultramarine with a little Indian red.

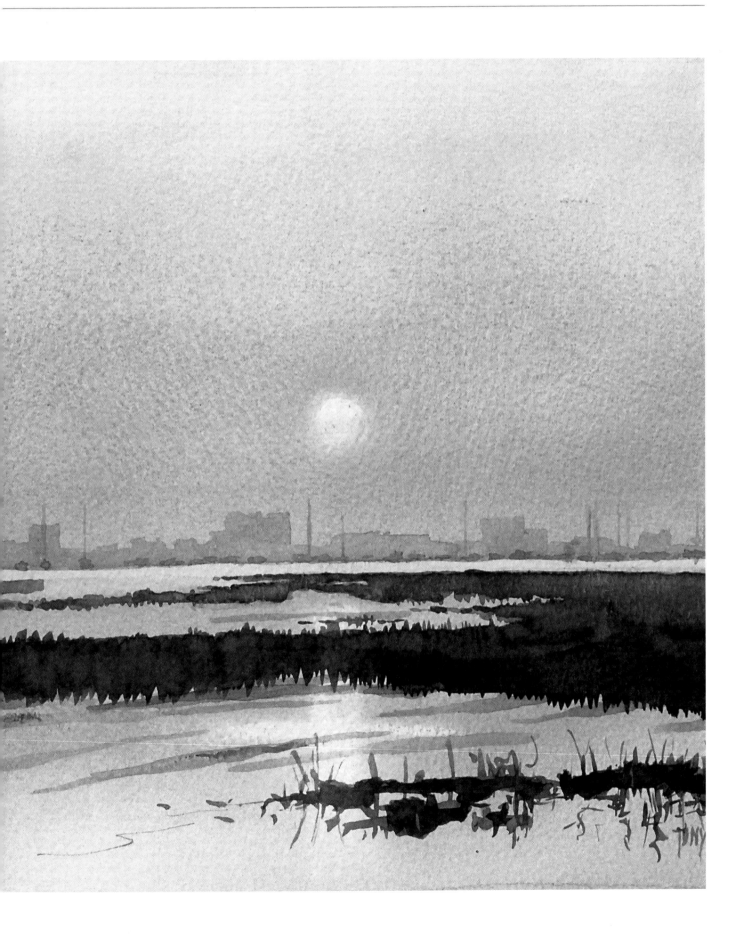

FRENCH ULTRAMARINE – Pigment Blue 29

ORIGINS

Ultramarine pigment used to be made by powdering the semi-precious stone, lapis lazuli. The cost of producing the pigment was very high, so in 1828 the Society for the Encouragement of National Industry, based in France, sponsored a competition to find a cheaper alternative. J.B. Guimet, a Toulouse chemist, noticed a mysterious blue deposit in soda ash furnaces which, when analyzed, turned out to be chemically similar to genuine ultramarine. What's more, it could be produced in quantity at a reasonable price. Discovered almost by accident, it is now one of the mainstays of the artist's palette.

COLOUR MIXING CHART

1 French ultramarine is a strong rich blue that, in dilution, tends to flocculate to give a grainy effect.
2 Mixing white with French ultramarine naturally makes it paler, but it also takes some of the zing out of the colour, which then appears chalky. Note that the graininess of the colour is reduced when white is added.
3 Aureolin is a strange, transparent yellow with an ochre coloured mass tone. The diluted colour is greenish. Mixing aureolin with ultramarine gives a soft greyish-green.
4 Cadmium yellow's orangey bias argues with the blue to create a muted green that has an olive character, very useful in all landscape work.
5 Adding yellow ochre to ultramarine gives the resulting green a greyish character which, like all ultramarine mixed greens, is excellent in landscape work.
6 The opaque, orange bias of cadmium red fights the ultramarine blue to produce a lovely muted burnt purple. A very useful colour for all subject matter from portrait to landscape.

French Ultramarine Mixing Chart

7 The clean colour obtained from mixing permanent rose and ultramarine is achieved for two reasons: firstly, the biases of both the blue and the rose lean towards purple and, as the mix of red and blue will make purple, there is no conflict. Secondly, both colours are transparent and the reflection of light from the paper below aids its luminosity.
8 Burnt sienna is a hot, grainy red-brown that is neutralized by the blue to give a range of greys, – brownish or bluish – depending on which colour dominates.

PROPERTIES
PERMANENCE: ASTM D4302 Class I (excellent lightfastness); Blue Wool Scale 8 (absolutely lightfast).
COLOUR BIAS: Towards violet.
TRANSPARENT/OPAQUE: Semi-transparent.
STAINING: No.
HAZARDOUS: Not considered hazardous.
TINTING STRENGTH: High.
CHARACTERISTICS: The purplish bias of the colour ensures that good, clean mauves and violets can be achieved. However, don't expect clear, sharp greens by adding yellow. The purplish bias of the pigment ensures that all greens are muted.

WATERCOLOUR: A very popular and useful pigment for watercolour use. As they dry, the pigment particles tend to flocculate (be attracted into minute clots) rather than dispersing into an even wash. This gives a pleasant texture that is used to great effect by many watercolourists.
OIL: French ultramarine has a high oil absorption, is slow drying and produces a hard, somewhat brittle paint film. It is a good mixing colour and its beautiful rich transparency makes it an ideal glazing colour. Used unmixed, in thick impasto, it is very dark and dull.
OTHER MEDIA: Suitable for use in all media.

A visually equal mix applied densely will give a soft black, much used by watercolourists.

9 The grainy and opaque coeruleum mixes with ultramarine to give an unusual and fairly neutral blue, that could be usefully employed in skies and water. Flower painters may also find this mix useful. As both colours are grainy the mix is quite granular.

10 The grainy and transparent viridian blends with ultramarine to create a cooler, dark green, less raw than the viridian.

11 Mixing burnt umber in equal proportions with ultramarine will give a neutral, cold grey. Dense mixes will create a black that is softer and more variable (and in oil will be quicker drying) than most other blacks. By adding more of one colour than the other, the blacks can be made brown-black or blue-black.

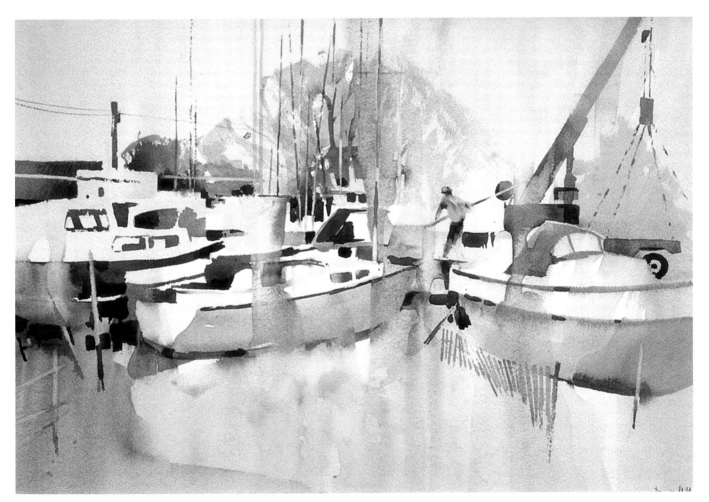

KEYHAVEN BOATYARD
DENNIS HILL
watercolour; 330 x 510mm (13 x 20in)

A mix of ultramarine and aureolin was used to make the greens, with ultramarine and mixes of burnt sienna and rose madder used for the rusty reds. The darks and the washed-down blues of the boats were mixes of ultramarine broken with rose madder. A touch of yellow ochre was used for the figure.

COERULEUM (Cerulean) – Pigment Blue 35

ORIGINS

This greenish-blue was first introduced to the artist's palette by George Rowney in 1870. Daler-Rowney still retain their original spelling, but most manufacturers have adopted "cerulean" as an easier name. As the pigment is expensive it is substituted by cheaper alternatives in student ranges. Substitute pigments are often based on phthalocyanine blue and titanium white; sometimes with other toning colours added.

COLOUR MIXING CHART

1 As the colour is diluted it becomes quite grainy in character.

2 When mixed with white the graininess disappears and the colour does not become chalky looking, largely because of its opacity.

3 Lemon yellow's greenish colour marries with coeruleum to produce a lovely soft, fresh green, ideal for spring foliage and sunlit lawns.

4 The brownish bias of yellow ochre reacts with coeruleum's green bias to produce a duller, but more useful green. The graininess of the mixed colour is evident. Both colours are opaque.

5 Cadmium scarlet – another opaque colour – mixes with coeruleum to produce some excellent subtle brownish-purples and greys.

6 I love this purple. Made from coeruleum and alizarin crimson, the greenish tinge of coeruleum imparts a clean delicacy to the mixed colour.

7 Indian red – opaque and powerful – mixes with the blue to produce a range of darkish neutral colours with a hint of purple. Used subtly this is an excellent mix for portrait and figure work.

Coeruleum Mixing Chart

8 Although the greenness of coeruleum has a dulling effect on the red leanings of permanent mauve (dioxazine violet), the resultant colour is a beautiful one, universally useful.

9 The addition of coeruleum to French ultramarine subdues the latter's reddish leanings and makes the colour much more neutral – more like cobalt blue.

10 Viridian green already leans towards blue, coeruleum leans to green. Therefore, it is not surprising that a mix

PROPERTIES
PERMANENCE: ASTM 4302 Class I (excellent lightfastness); Blue wool scale 7 (absolutely lightfast).
COLOUR BIAS: Towards green.
TRANSPARENT/OPAQUE: Opaque.
STAINING: No.
HAZARDOUS: The modern colour is not considered hazardous. Older colours, produced since 1978, will have a hazard warning symbol if they contain any hazardous substances. For a tube or pan that pre-dates 1978, it would be wise to treat it as having a hazardous element.
TINTING STRENGTH: Medium to low.
CHARACTERISTICS: Coeruleum is the only truly opaque blue in the artist's palette. At full strength it is pale when compared to other blues. Often used unmixed for skies, it is

a good mixing colour, capable of producing great subtlety.
WATERCOLOUR: Coeruleum is not a very good colour if transparency is needed. A wash of coeruleum over another colour will look like a grainy pale blue veil. This, of course, can be used to effect if desired, but if transparency is required then Manganese blue – a cleaner but similar shade – should be used.
OIL: The cobalt element in the pigment makes it a medium-fast drier and, when dry, it gives a fairly flexible paint film. Its oil absorption is very high and so it is better used in the upper, rather than lower layers of a painting. Mixed with white and applied as a thin veil, it is excellent for creating distance in a landscape.
OTHER MEDIA: Can be used in all media except in pastel, where the original pigment will be replaced by a hue colour.

of these two colours produces a blue-green. The blue has the effect of taking some of the rawness off the green. A useful mix for marine work and shadow foliage. As both pigments are grainy the resulting mix is similarly granular.

11 Blue and brown always give a neutral colour. Here raw umber has been mixed with coeruleum. This gives a range of greyish colours. Adding white can vary the effects of the colour.

12 The redder, more transparent burnt umber gives a warmer neutral colour when the brown is dominant and a solid neutral grey when the blue dominates. Both the raw and burnt umbers make wonderful mixes for landscape work.

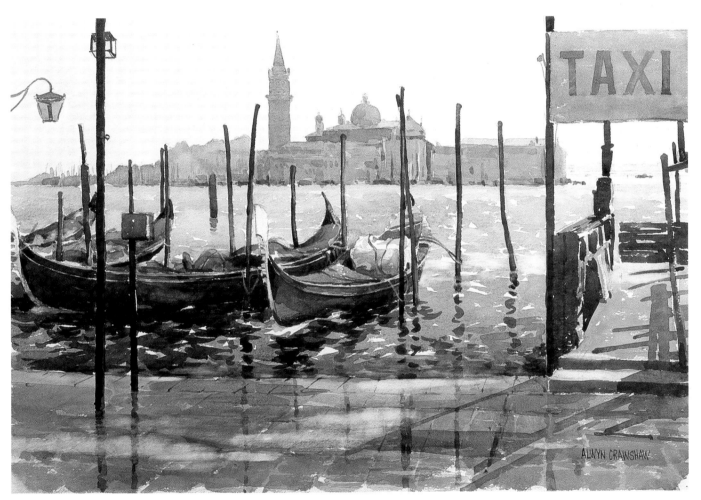

TAXI! VENICE
ALWYN CRAWSHAW
watercolour; 380 x 508mm (15 x 20in)

Ultramarine, yellow ochre and alizarin crimson were used in dilute washes for the sky. The same colours applied wet-in-wet, but with less water, were used to model the buildings on the horizon. Coeruleum, Hooker's green dark and ultramarine were used for the water. This contrasted well with the ultramarine that was used for the covers on the gondolas. The yellow ochre and alizarin crimson gave strong sunlight to the taxi-landing stage and the shadows were created with ultramarine, alizarin crimson and a little yellow ochre.

PRUSSIAN BLUE – Pigment Blue 27

ORIGINS

This inorganic synthetic pigment was discovered in Prussia in 1704 and was introduced into the artist's palette in 1724. The colour is immensely powerful and very little really does go a long way. The bias is greenish, but in mass tone there is a bronze sheen. The colour has various aliases such as: Paris blue, mineral blue, Berlin blue, milori blue, iron blue and Chinese blue. Because of the varying quality of the raw pigment it has received a diverse press. Some artists swear by it, others refuse to use it. In premier manufacturers' ranges the colour should be reasonably reliable.

COLOUR MIXING CHART

1 Very dark when dense, the colour thins to reveal a greenish-blue in tints.

2 Adding white to make the colour paler does not affect the purity of the colour.

3 Cadmium yellow pale leans slightly to orange. When this is mixed with Prussian blue – with its greenish bias – a good range of greens result. They are not as acid as a mix with lemon yellow would have been. As with the other cadmium colours, the yellow is opaque. This gives the colour a slightly dusty character.

4 Cadmium orange gives an altogether different green, more olive and dusty.

5 Raw sienna is brownish compared to the orange, so, as you might expect, the mixed colour is duller. Unlike the last mix it doesn't have a dusty look as both colours are transparent. The raw sienna pigment causes the mix to be granular.

6 Orangey cadmium scarlet mixes with greenish Prussian blue to produce a soft, dusty, muted purple.

Prussian Blue Mixing Chart

7 The purplish alizarin crimson mixes with Prussian blue to give a clear, if slightly muted, deep purple and violet.

8 Some of the heat is taken out of burnt sienna in this mix. The result is a very useful range of dullish granulating grey-greens.

9 Raw umber hasn't got the heat of burnt sienna but a lot of soft greens can be obtained. Superb for landscape.

PROPERTIES

PERMANENCE: ASTM D4302 Class I (excellent lightfastness); Blue wool scale 7 (absolutely lightfast).

COLOUR BIAS: Greenish, but a bronze sheen is evident when the paint is applied densely.

TRANSPARENT/OPAQUE: Transparent.

STAINING: Strongly so. Use the colour sparingly.

HAZARDOUS: Despite the awful sounding chemical composition – ferro ferrocyanide – it is non-hazardous.

TINTING STRENGTH: Very high, use sparingly.

CHARACTERISTICS: Prussian blue is a slightly greener but otherwise similar colour to phthalocyanine blue which has largely replaced it and is more reliable. However, there are still painters who prefer the older pigment.

WATERCOLOUR: Prussian blue is a lovely greenish-blue, slightly duller than phthalocyanine blue. It flows easily to give a flat, even wash, but can sometimes fade in daylight, only to recover its colour during the hours of darkness. It is a strong stainer.

OIL: When applied thickly, it appears black with a bronze sheen. It is much better used thinly, particularly in mixes. Despite its high oil absorption, the iron element in the colour means that it dries moderately quickly to give a hard and fairly flexible paint film.

OTHER MEDIA: Prussian blue is suitable for use in all modern media.

10 Roasting raw umber pigment gives burnt umber. It is redder and mixes with Prussian blue to give fairly neutral greys which hint at green. Again, this is a wonderful, granular mix for landscape.

11 Adding Prussian blue to opaque oxide of chromium is a good way of deepening the tone of the green without changing its character too much. The green does become slightly colder.

THE BARN OUT BACK OF "NOISY" DAVE'S
TONY PAUL
egg tempera on gesso panel; 400 x 300mm (16 x 12in)

All of the blues in this painting are Prussian blue. I did have to be careful with it because of its power. I used it mixed with alizarin crimson for the shadow areas and with raw umber for the cooler areas of the planking and beams. Mixing Prussian blue with more alizarin and white gave the delicate purple of the board lying on the ground by the chicken and the door hinges. A stronger mix, without white, was used for the interior of the overturned food bowl. Other colours used were burnt sienna, cadmium red and raw sienna.

COBALT BLUE – Pigment Blue 28

ORIGINS

Discovered by Thénard (chemist, 1777–1857) in France in 1802, it was in general use by the mid-1820s. It was introduced at about the same time as French ultramarine and these two colours joined Prussian blue to give the artist a reliable set of blues, rendering the old smalt pigment, which was coarse and tinctorially weak, obsolete.

The Impressionists liked cobalt blue. It was not as deep in tone as French ultramarine, but was lively and mixed well with other pigments to make rich and clean colours.

All cobalt colours are expensive and in student ranges are approximated as "hues" using mixes of the cheaper phthalocyanine blue and French ultramarine.

COLOUR MIXING CHART

1 Here we can see the bright cobalt blue which granulates slightly in watercolour.
2 When mixed with white it loses some of its "zing" and the grainy quality is compromised. Pale tints tend to look chalky, particularly if potent titanium white is used.
3 Lemon yellow leans towards green and although cobalt mixes to give a reasonable green it has a soft edge to it, with a hint of grey – probably because of its slight leaning to purple.
4 Cadmium yellow's orangey bias argues with the hint of purple in cobalt to give a fairly cold, muted green – the cool of shaded lawns. Don't forget to add the powerful cadmium to the cobalt in small amounts, or you'll end up mixing more paint than you need.
5 Any brownish colour mixed with blue tends towards grey and the mixing of raw sienna with cobalt blue is no exception. A greenish-grey results. In watercolour this is quite grainy – both colours contributing to this effect.
6 Cadmium red leans towards orange and therefore a

Cobalt Blue Mixing Chart

sharp purple is not possible; but the mix created is a clean burnt purple with a rich quality.
7 To get a rich purple that has an inner glow, mix alizarin crimson with cobalt blue. Alizarin is a lightweight pigment and cobalt a heavy one. In watercolour these tend to separate slightly in a wash, to give an optical sparkle to the mix.
8 The dull purplish undertone of Indian red mixed with cobalt gives a sombre, but live, grey-purple hue. It is ideal for use in landscapes, portraits or other subjects

PROPERTIES
PERMANENCE: ASTM 4302 Class I (excellent lightfastness); Blue wool scale 7–8 (absolutely lightfast).
COLOUR BIAS: Fairly neutral but leaning towards purple.
TRANSPARENT/OPAQUE: Semi-transparent.
STAINING: No.
HAZARDOUS: The modern colour is not considered hazardous. Older colours, produced since 1978, will have a hazard warning symbol if they contain any hazardous substances. For a tube or pan that pre-dates 1978, it would be wise to treat it as having a hazardous element.
TINTING STRENGTH: Low to medium.
CHARACTERISTICS: A pleasant colour when used unmixed, it makes clean colours in mixes.

WATERCOLOUR: Cobalt blue in the pan form is difficult to work into a full-blooded wash, probably because it is a weakish colour. Tubed colours handle better, but a lot of paint will be used to get a reasonable wash strength. Cobalt blue granulates slightly and mixes easily with other colours.
OIL: It handles and mixes well but the oil absorption is very high. This can cause the colour to yellow in time, particularly if further oil is added when mixing. It dries reasonably quickly to give a hard and fairly flexible paint film. When applied unmixed it is better used in the upper layers of a painting. The dry paint film can look dull but varnishing will restore its freshness.
OTHER MEDIA: Can be used in all media except in pastel, where the original pigment will be replaced by a hue colour.

where an off-black with depth is required.
9 Mediterranean deep-sea marine subjects would benefit from this colour made from viridian and cobalt blue. The result is a clear and clean green-blue, as sharp and acid as you could wish for.
10 Cobalt blue's cousin, cobalt magenta (also known as cobalt violet) is a little on the mauvish side; adding cobalt blue will help take the colour towards violet. In watercolour, cobalt violet is grainy, weak, streaky and gummy. Adding cobalt blue both strengthens the colour and reduces its streaky quality. A more fade-free light purple would be hard to find.

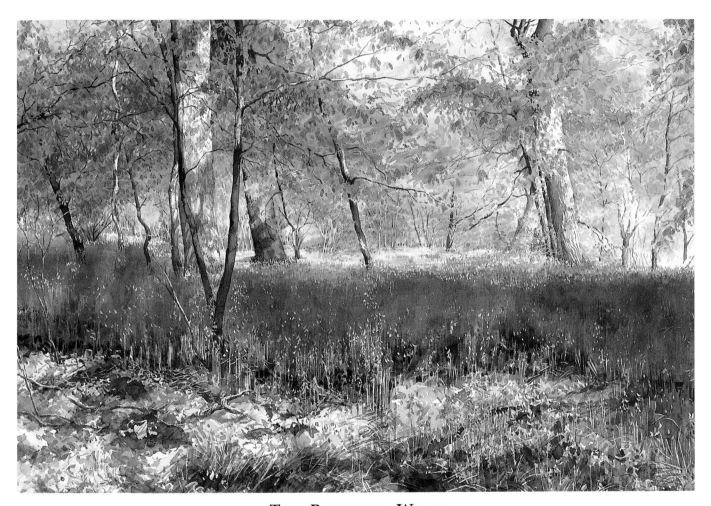

THE BLUEBELL WOOD
FRANCES SHEARING
watercolour; 355 x 560mm (14 x 22in)

The darker green of the trees was mixed from cobalt blue and aureolin, while the distant foliage was Naples yellow and cobalt blue, which gave a more muted colour. The bluebells were painted with the cobalt blue warmed with alizarin crimson. The foreground was developed with dilute washes of Naples yellow and vermilion, with the dark greens made of cobalt blue with some aureolin.

PHTHALOCYANINE BLUE – Pigment Blue 15

ORIGINS

Some painters looking at the name of this colour may well think they have never heard of it, but I would guess that many already use it. Because of its difficult to pronounce name, it has been given many aliases, such as: monestial blue, Winsor blue, mona blue, phthalo blue, thalo blue, etc. Invented in England in 1935, it was introduced into the painter's palette in 1936.

Phthalocyanine blue is similar in colour to Prussian blue, but is more reliable and reasonably priced. Because of its greenish leanings, it is used in student ranges and pastels to create "hue" colours that imitate the expensive coeruleum and, in combination with French ultramarine, it makes a good substitute for cobalt blue.

COLOUR MIXING CHART

1 Phthalocyanine blue gradates evenly to provide a smooth wash.

2 Even when mixed with a large amount of white, phthalocyanine blue retains its clarity.

3 As the blue leans towards green, mixing it with lemon yellow, which is also greenish, results in a sharp, clear green. Substituting yellows with an orange bias will give a rounder and warmer green.

4 Mixing it with the brownish raw sienna results in a very dull and dark green, which has a kind of richness. This would be a very useful landscape colour. The granular quality of raw sienna gives a watercolour wash character.

5 The opaque cadmium orange mixes to give a dusty looking grey-green. This dusty quality is probably created by the dense opacity of the orange.

6 This dusty quality is also evident when the blue is mixed with cadmium red. The result is a muted greyish-purple with a degree of heat as an undertone.

7 Despite the blue's green bias it has good tolerance to red and the resulting alizarin crimson mix gives a fairly

Phthalocyanine Blue Mixing Chart

clear purple that is rich and full. Both alizarin crimson and phthalocyanine blue are transparent and this gives the mixed colour plenty of depth.

8 Another transparent colour, permanent rose, has a sharp purplish hue. This pigment mixes with the blue to produce a slightly more delicate purple than with alizarin crimson.

9 The purplish leanings of Indian red combine with the blue to create a subdued purplish-brown when the red is dominant, and a restrained indigo colour when the emphasis of the mix is on blue. As is usual with binary mixes, the colours have a kind of under-glow.

PROPERTIES

PERMANENCE: ASTM D4302 Class I (Excellent lightfastness); Blue wool scale 8 (absolutely lightfast).

COLOUR BIAS: Generally towards green, but variants leaning towards purple are available.

TRANSPARENT/OPAQUE: Transparent.

STAINING: Strongly staining.

HAZARDOUS: The modern colour is not considered hazardous. Older colours, produced since 1978, will have a hazard warning symbol if they contain any hazardous substances. For a tube or pan that pre-dates 1978, it would be wise to treat it as having a hazardous element.

TINTING STRENGTH: Very high.

CHARACTERISTICS: An intense blue which, when diluted considerably, will give a greenish, almost coeruleum, hue.

WATERCOLOUR: It is very economical in use and gives even, grain-free washes. However, it will stain watercolour paper and is unlikely to wash out if an error is made.

OIL: Being transparent, it is best used in glazing techniques or when reduced with white. Used unmixed in thick applications it will appear dull and black. Its average to slow drying speed and high oil absorption mean that, unmixed, it would be better employed in the upper layers of a painting.

OTHER MEDIA: Suitable for all other media.

10 Burnt umber and phthalocyanine blue combine to produce a range of neutral greenish-grey colours. Again, these are useful in landscape work and will act as a foil for purer colours.

11 Cobalt blue can be imitated by adding French ultramarine to phthalocyanine blue. The respective purple and green biases cancel each other out to create a fairly neutral blue.

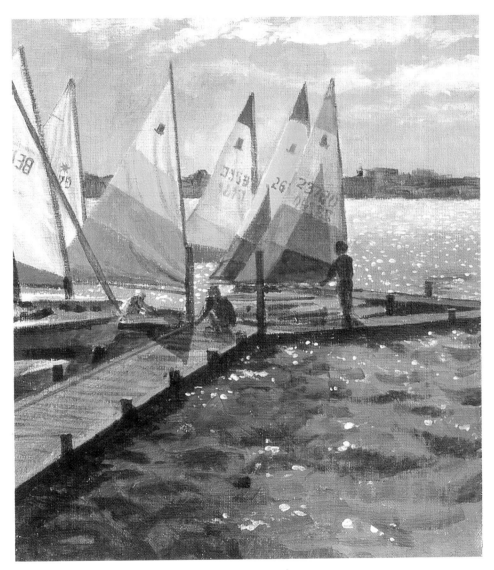

DINGHIES
TONY PAUL
acrylic on board; 217 x 190mm (9 x 7in)

The only blue used was phthalo blue. For the sky I mixed it with white, with a little yellow ochre blended in at the horizon. This was pulled down for the distant sea and the amount of phthalo blue increased as it came forward. A green was made by mixing a little cadmium yellow and used to model the dark ripples on the water. The darks were made from phthalo blue and raw umber with the planks of the walkways made by adding white to this mix. The reds, oranges and yellows were made from permanent rose and cadmium yellow in various mixes.

INDANTHRENE BLUE – Pigment Blue 60

ORIGINS

Indanthrene blue is an unexciting but very good pigment that will not take the place of any of the established blues. When used densely it has the character of indigo, if slightly bluer, but being a mono-pigment without the added black that indigo usually has, mixes will be cleaner. Adding a tiny amount of burnt umber will create a close match for Payne's gray or, with a touch of alizarin crimson instead, a neutral tint can be made.

COLOUR MIXING CHART

1 The blue-black character of indanthrene blue is evident.

2 See how dull indanthrene blue is (b) compared to French ultramarine (a) and phthalocyanine (phthalo/monestial/Winsor) blue (c).

3 Adding white gives a soft and subtle dusty colour.

4 Its purple leanings compete with the green undertone of lemon yellow to make a cold blue-green for winter landscape.

5 The warmer gamboge hue gives a sunnier green, useful for landscape work.

6 A mix with cadmium orange makes neutral greeny-greys. These colours make wonderful foils for brighter hues.

7 Vermilion hue is subdued by the blue and makes a dull purple, useful for shadowed darks.

8 A clearer result is obtained from permanent rose, useful in flower subjects.

9 The orange bias of burnt sienna is killed by the blue to give colours ranging from a dull brown to a neutral grey.

10 Dull brown-greys and grainy blue-black are made when the blue is added to burnt umber.

11 The greenish undertone of coeruleum diminishes as the blue is added, giving an unusual, beautiful, grainy blue.

12 Viridian is softened when mixed with the blue – useful for foliage in landscape shadows.

Indanthrene Blue Mixing Chart

PROPERTIES

PERMANENCE: ASTM 4302 Class I (excellent lightfastness); Blue wool scale 7–8 (absolutely lightfast).

COLOUR BIAS: Towards violet.

TRANSPARENT/OPAQUE: Semi-transparent.

STAINING: Yes.

HAZARDOUS: Not considered hazardous.

TINTING STRENGTH: Medium.

CHARACTERISTICS: It is rather like an ultramarine that has been neutralized with black or a deep brown.

WATERCOLOUR: When applied as a wash it goes on densely but dries paler and duller. The wash is even and mixes easily with other colours.

OIL: The oil absorption is high. It is an average drier giving a hard, fairly flexible paint film, best used in the upper layers of a painting.

OTHER MEDIA: Indanthrene blue is compatible for use in all other media.

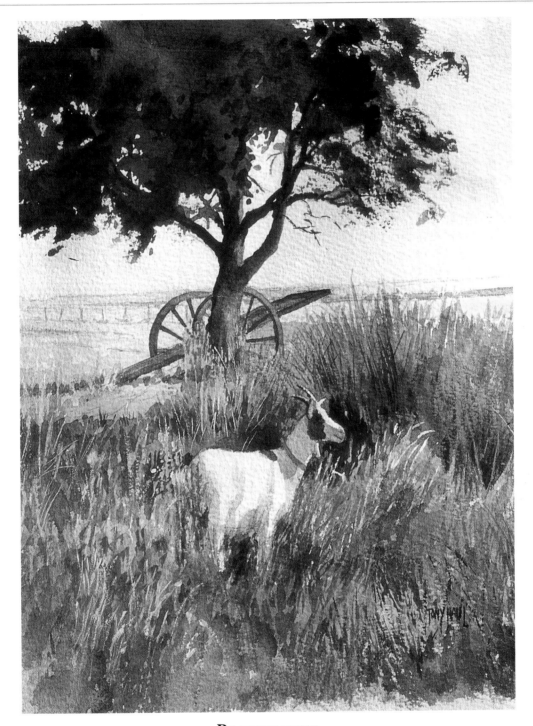

PAQUERETTE

Tony Paul

watercolour; 240 x 195mm (9 x 8in)

Most greens in the painting were made from indanthrene blue mixed mainly with lemon yellow, but gamboge hue was used in the richer greens. In the tree's canopy, burnt umber was dropped in to warm and darken it further. The goat's shading was manganese blue, broken with a little permanent rose. Various colours were dropped into the grass – raw sienna, Indian red and cadmium orange – and the tree trunk and branches were indanthrene blue with burnt umber.

MANGANESE BLUE – Pigment Blue 33

ORIGINS

The pigment, manganese blue, is no longer manufactured in its original form. It was in oil, acrylic and watercolour ranges up to the end of the 1970s, but by the mid-1980s, was only found in some manufacturers' watercolour ranges. As its use declined, so the cost went up, further reducing its popularity. Superficially it resembles coeruleum, but it is quite different, being cleaner, slightly greener and much more transparent. As it is not a popular choice you will be likely to find that it is still available in your local art shop. I think that it is a wonderful pigment in watercolour. True, it is not easy to use, being a weak colour and rather gummy in consistency, but it is really lovely.

Nowadays, when it appears in manufacturers' ranges it will be labelled as "hue". This indicates that the colour has been synthesized using other pigments. It is made from phthalocyanine blue which normally dries to a flat, evenly gradated wash, in contrast to real manganese blue which is quite granular.

COLOUR MIXING CHART

1 Manganese blue is a lovely clean colour. Its granular character is enhanced when mixed with some pigments.
2 When combined with white there is very little change in the colour except that it does become less grainy.
3 Compare manganese blue with coeruleum – manganese blue makes the opaque coeruleum look quite dull.
4 Lemon yellow mixes with manganese blue to create a sharp, clean green, ideal for sunlight through leaves.
5 The orangey gamboge hue argues a little with manganese blue to give a warmer and softer, light green.
6 Orangey cadmium red is exactly the complementary colour of the greenish blue. The red is cancelled out by

Manganese Blue Mixing Chart

the green bias of the blue and the blue attacks the orange bias of the red. The result is a dull, rusty purplish colour.
7 The purplish undertones of permanent rose have sympathy with the blue. The greenish bias of manganese blue softens the purple colour.
8 Indian red too, has a purplish undertone. The mix veers between a dull rust colour and a dark, steely grey – excellent for aspects of landscape work.
9 The yellowish light red gives a warmer, more neutral range of colours.
10 Mixing manganese blue with French ultramarine gives a fairly neutral blue, approaching cobalt blue in an equal mix.

PROPERTIES
PERMANENCE: Original pigment ASTM 4302 Class I (excellent lightfastness); Blue wool scale 7 (absolutely lightfast).
COLOUR BIAS: Towards green.
TRANSPARENT/OPAQUE: Transparent.
STAINING: No.
HAZARDOUS: The modern colour is not considered hazardous. Older colours, produced since 1978, will have a hazard warning symbol if they contain any hazardous substances. For a tube or pan that pre-dates 1978, it would be wise to treat it as having a hazardous element.
TINTING STRENGTH: Low.

CHARACTERISTICS: A lightfast greenish-blue, of great value in watercolour.
WATERCOLOUR: A superb green-blue that makes singing, soft greens and delicate purples. However, it is a weak pigment and therefore quite difficult to handle in broad washes.
OIL: A good glazing colour. Its very high oil content relegates it to use in the upper layers of a painting, where it dries reasonably quickly to give a hard and fairly flexible paint film.
OTHER MEDIA: Can be used in all media except in pastel, where the original pigment will be replaced by a hue colour.

11 Cobalt violet (cobalt magenta) is another weak, gummy pigment. A mixture of this with manganese blue is hard to handle, but it does give some interesting muted violet colours.

12 The grainy viridian and manganese blue make a bright blue-green, evocative of Caribbean seas. Substituting phthalo (monestial/Winsor) green for the viridian would produce an even brighter Caribbean blue.

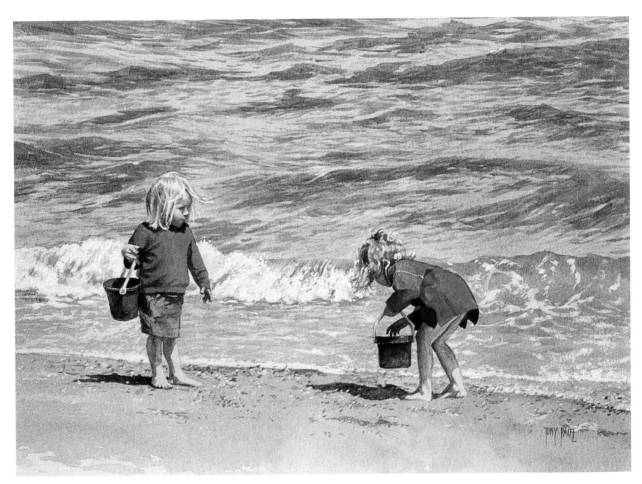

THE BLUE BUCKET
TONY PAUL
watercolour; 300 x 400mm (12 x 16in)

A pale wash of ultramarine was placed over the entire sea area before modelling the wave forms in raw sienna. Over this I laid the detail of the waves in transparent manganese blue. In the near wave on the right I made its crest of manganese blue with a little raw sienna, adding more sienna, then washing in ultramarine for the wet sand. The blue bucket is made from a mix of ultramarine and manganese blue, and the beach is a mix of raw sienna and manganese blue. Similar colours were used in the girls' hair with gamboge hue to brighten it. The girl on the left wears a jumper of vermilion hue, cooled with alizarin, while the other girl's shirt is of alizarin crimson cooled with manganese blue. The whites of the water were mainly masked out prior to painting, with touches of white gouache added to finish off.

COBALT VIOLET (Cobalt Magenta) — Pigment Violet 14

ORIGINS

Originally discovered in the 18th century, cobalt violet was originally prepared from a semi-rare cobalt ore that gave a reddish hue. Soon afterwards it was made synthetically and a true violet colour was made available. Currently, it is produced in two basic hues: light – a reddish, subtle colour and deep – a blue violet. The original recipe contained arsenic, but this component is no longer used because of its highly poisonous nature. It is a very weak pigment and is expensive, but there is nothing quite like its clarity and subtlety in the range of violet colours. It is particularly prized by flower painters.

COLOUR MIXING CHART

1 The streaky character of cobalt violet can be seen. It has a grainy character, which is particularly evident in mixes.

2 Adding a dense white, such as permanent white gouache, knocks the depth out of the colour, giving it a cool, chalky look.

3 I was surprised at the warmth of the colour when cobalt violet and lemon yellow were mixed. Hues varying from an ochre colour to a soft tan were obtained.

4 A slightly more subtle pale tan was obtained when cadmium yellow was used.

5 Although some of the vibrancy is taken out of cadmium red by the violet, the colour produced is rich yet subtle.

6 Permanent rose and cobalt violet combine to give a superb, delicate soft mauve, which is quite granular.

7 The slight purplish leaning of Indian red is reinforced

Cobalt Violet Mixing Chart

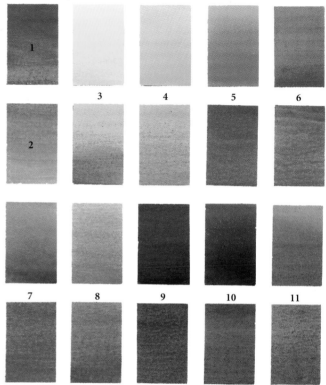

by adding cobalt violet. Another beautifully subtle colour, useful in landscape, portrait or any other subject.

8 Whatever you mix with coeruleum a good colour seems to result. The muted purple produced by the mix is one of my favourites.

9 A clearer purple is produced by introducing French ultramarine to cobalt violet.

PROPERTIES

PERMANENCE: ASTM D4302 Class I (excellent lightfastness); Blue wool scale 7–8 (absolutely lightfast).

COLOUR BIAS: Either towards red or towards blue.

TRANSPARENT/OPAQUE: Semi-opaque.

STAINING: No.

HAZARDOUS: The modern colour is not considered hazardous. Older colours, produced since 1978, will have a hazard warning symbol if they contain any hazardous substances. For a tube or pan that pre-dates 1978, it would be wise to treat it as having a hazardous element.

TINTING STRENGTH: Very weak.

CHARACTERISTICS: A lovely colour, useful in all subjects but it is easily overpowered in mixes. Always add other colours to cobalt violet or you will need a vast amount of the colour to get even a reasonable balance. In mixes it gives a good range of subtle colours. Sometimes the colour is strengthened by adding cobalt blue, manganese violet or quinacridone (PV19). This will make the colour more powerful, but it will probably lose some of its delicacy.

WATERCOLOUR: A difficult colour to use in broad washes. It tends to go streaky and is very gummy and stiff in consistency. However, it is worth using as few other colours can achieve its delicacy. Even a small wash will need a large amount of pigment. Avoid over-painting with other colours. The cobalt will lift off.

OIL: Cobalt violet's low to medium oil absorption and medium to fast drying speed make it ideal for use in the under-layers of a painting. Despite its semi-opacity, its weak tinting strength makes it cover poorly. Again, it is somewhat streaky in use. The dried paint film will be hard and fairly flexible.

OTHER MEDIA: Can be used in all media except in pastel, where the original pigment will be replaced by a hue colour.

10 The greenish leaning of phthalocyanine blue (phthalo/monestial/Winsor) argues with the reddish-violet to produce a clear but muted purple, ideal for indicating shadows.

11 A greyish neutral colour is made from a phthalocyanine green/cobalt violet mix. Useful for shadow work in landscape as it can be veered from a cool, dark green to a greeny-grey which is quite dusty in character.

A HOUSE IN SAN GIMIGNANO, TUSCANY
FRANCES SHEARING
watercolour; 406 x 559mm (16 x 22in)

Cobalt violet was used with coeruleum, permanent mauve and Naples yellow for most of the stonework in the painting. Its pinkish undertone gives a warm delicacy to the texture of the stonework. The tree greens were of yellow ochre and ultramarine, the bright pinks of the flowers were permanent rose and alizarin crimson, with a little permanent mauve used in the shadows.

BROWNS

Raw Umber 98

Burnt Umber 100

Burnt Sienna 102

Mars Violet 104

Light Red 106

Indian Red 108

RIGHT Harvesting – Amish Farmlands, Pennsylvania; *acrylic; by Tony Paul. Lemon yellow, yellow ochre, raw sienna, burnt sienna, phthalo green, ultramarine, permanent rose, coeruleum and burnt umber were used in this work.*

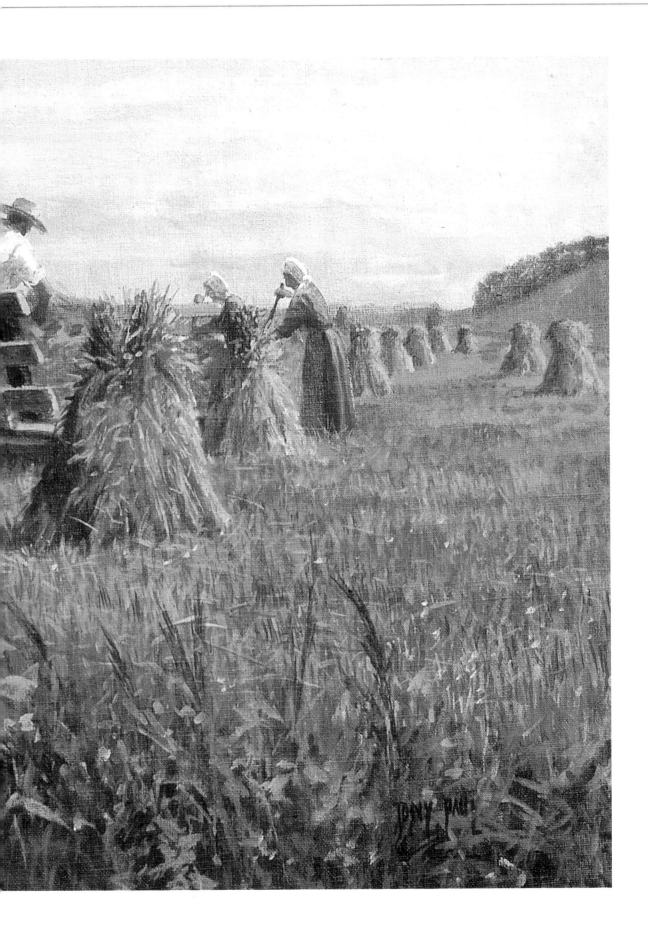

RAW UMBER — Pigment Brown 7

ORIGINS

Raw umber originated from Italy and the eastern Mediterranean. It can vary in tone and colour, depending on the area of origin.

COLOUR MIXING CHART

1 Two different variants of the raw umber pigment were used in the chart: (a) is yellowish and the undiluted colour is not as deep in tone as (b), which is fairly neutral, being greyish when diluted.

2 (a) and (b) Neither of the two varieties are very transparent, their colours change little when mixed with white, as compared to the diluted colours. There is only a slight tendency to chalkiness.

Raw Umber Mixing Chart

PROPERTIES

PERMANENCE: ASTM D4302 Class I (excellent lightfastness) Blue wool scale 8 (absolutely lightfast).

COLOUR BIAS: Varies: yellowish, greenish, greyish or purplish.

TRANSPARENT/OPAQUE: Semi-transparent.

TINTING STRENGTH: Medium to low

STAINING: No.

HAZARDOUS: Not considered hazardous.

CHARACTERISTICS: A generally dark brown that is rather lifeless when used thickly. It comes into its own when diluted or reduced with white, to reveal its undertone. The colour is often recommended to tint a canvas prior to painting a portrait. Its neutrality, particularly when mixed with white, is an excellent foil to flesh colours.

WATERCOLOUR: Some varieties have a dirty quality when used diluted and are probably best used in mixes where they excel. Others are pleasant diluted straight from the tube or pan. Raw Umber is a granulating pigment.

OIL: Raw umber produces a flexible, tough and leathery paint film. Despite the pigment's high oil absorption, it is often used well diluted and mixed with low oil colours – such as flake white – to lay in a tonal under-painting. The manganese content ensures that the paint dries quickly.

OTHER MEDIA: The pigment works well in all media, but in some ranges the colour is synthesized using alternative pigments.

3 Gamboge hue is a warm yellow when applied densely but thins to become fairly neutral. Raw umber is a brilliant darkening colour for yellows and variant (a) is particularly good as it has a yellowish bias.

4 When mixed with cadmium red, the biases of the two umbers create a different emphasis to the mixed colour. The yellow bias of (a) results in a warm red-brown, whereas (b) is cooler. Both are super colours, useful in both portrait and landscape work.

5 Permanent rose is a colour that will happily accommodate both cool and warm colours to make clean-cut secondaries. When (a) is added the result is a warm brown. Adding (b), the colour is much cooler and sharper.

6 Coeruleum is an opaque, granulating pigment, so in watercolour we can expect that the mix will be grainy. Once more, the biases of the pigments are in evidence. See how green the (a) mix is compared to the greyish (b) colour.

7 French ultramarine's purplish bias neutralized the yellow in raw umber (a) to give a neutral grey although, when the brown predominates, it is still greenish. Colour (b) is still colder. In watercolour, the flocculation of the ultramarine pigment combines with the granular quality of the raw umber to give a grainy wash.

8 The unnatural green, viridian, responds well under raw umber's influence to produce some excellent greens. The greens made with (a) are, as we have come to expect, much warmer and would relate well to summer or autumnal landscapes, whereas (b) looks more wintry. Again, the resulting mix is grainy.

9 Permanent mauve (dioxazine violet) combines with raw umber (a) to give a greeny brownish-purple, whereas (b) greys the violet so that it resembles mars violet. Both mixes are valuable as muted shadow colours as they will modify, rather than veil, the underlying colour.

GREY DAY, PORTSMOUTH
TONY PAUL
watercolour on oatmeal tinted Bockingford paper; 380 x 560mm (15 x 22in)

The palette is limited to raw umber, raw sienna, coeruleum and ultramarine, plus a touch of alizarin crimson hue and vermilion hue. The large ship on the left-hand side was painted with coeruleum and raw umber, while the stronger grey on the right-hand ship was raw umber with ultramarine. Raw sienna was used in the smaller vessel by the distant quay and for the quay itself. The tug was painted with ultramarine, coeruleum and raw sienna. The two reds were mixed to make the red in the Union Jack.

BURNT UMBER — Pigment Brown 7

ORIGINS

A historic pigment made by roasting the raw umber pigment, making it darker, more transparent and redder in bias, although the actual colour will vary from manufacturer to manufacturer. Being an earth colour, it is both cheap and lightfast and is probably in the palette of most artists.

COLOUR MIXING CHART

1 The brown is dark and rich when used densely, but when applied in thin washes it has a pleasant beige colour.
2 When white is added to burnt umber it subdues the reddish undertone to give a chalky look to the colour. This example was mixed with zinc white. Had I used titanium white, the chalkiness would have been even more pronounced.
3 Lemon yellow is a weakish colour and is easily overpowered. The resulting mix is rather like raw sienna or yellow ochre.
4 Gamboge hue has a warmer colour that is also stronger than lemon, so the mix will be a hotter colour.
5 Burnt umber has a deadening effect on cadmium scarlet, reducing its heat to a dull under-glow. Useful for autumnal scenes, as are most of these colour mixes.
6 The sharp coolness of permanent rose gives an altogether different red-brown.
7 Adding the red-brown of burnt sienna warms up burnt umber without affecting its tonal range too much.
8 Mixed with coeruleum blue, burnt umber produces a range of colours varying from a greeny-grey to a deep greenish-brown.
9 For those who dislike using black, mixing French ultramarine with burnt umber – in a visually equal mix – will give a blackish colour that is not as harsh as a true black. It is a doubly useful colour as it can be biased to give a brownish black or a blue black. If these mixes are

Burnt Umber Mixing Chart

diluted or mixed with white, a good range of useful greys can be obtained.
10 Viridian is a permanent, but rather unreal, green. When mixed with burnt umber, a range of really useful winter greens, greys and browns result. When used in pale washes, or reduced with white, these mixes give colours which vary from a soft, greenish-grey to a neutral beige.
11 Adding permanent mauve (dioxazine violet) to burnt umber gives a mix ideal for deep shadow areas in landscape work.

PROPERTIES

PERMANENCE: ASTM D4302 Class 1 (excellent lightfastness); Blue wool scale 8 (absolutely lightfast).
COLOUR BIAS: Varies depending on source; usually reddish, but some have a greyish or violet undertone.
TRANSPARENT/OPAQUE: Fairly transparent.
STAINING: No.
HAZARDOUS: Not considered hazardous.
TINTING STRENGTH: Medium to high.
CHARACTERISTICS: Burnt umber is, without doubt, the best deep brown in the artist's palette and is suited to all media.

WATERCOLOUR: One of the standard watercolour pigments. Washes can be granular.
OIL: Although an essential oil painter's pigment, it has to be used carefully. As it is fast-drying the unwary artist may use it unmixed for under-painting. Its high oil absorption is such that, unless greatly diluted by mixing it with a low or medium oil absorption pigment, in time it will cause superimposed layers of paint to crack. Burnt umber dries to give a hard but fairly flexible paint film.
OTHER MEDIA: Burnt umber is suited to all other media.

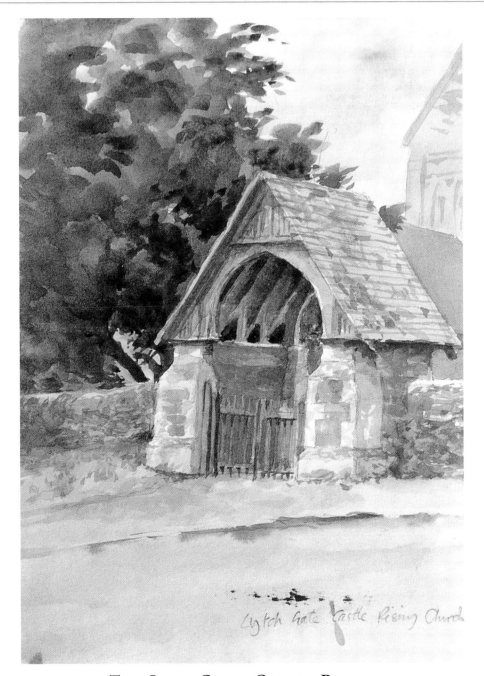

THE LYCH GATE, CASTLE RISING

TONY PAUL

Watercolour; 210 x 145mm (8¼ x 5¾in)

Burnt umber was mixed with phthalo green to make the greens of the tree beside the lych gate. The first layer was applied fairly dilute, with Indian red dropped into the wet wash. The second layer of denser paint was applied to give strong darks. Ultramarine was added to the wet colour to give the ultimate darks of the tree trunks. Pale washes of burnt umber were run over the gate roof, the brownish wall inside the gate and as an under-layer to the right-hand churchyard wall. The purplish-greys were made from ultramarine and Indian red, and the grass by the wall is ultramarine with raw sienna. Burnt sienna was used to warm the brickwork and a broken wash of manganese blue punched blue holes into the clouds in the sky.

BURNT SIENNA — Originally Pigment Brown 7

ORIGINS

A colour that will be found in the palette of most artists, no matter what medium they use. It used to be made by roasting raw sienna earth gathered from around Siena, Italy. The original pigment varied in quality and so has been substituted in most manufacturers' ranges with the synthetic mars colour (PR101). This is stronger, cleaner in hue and more lightfast than the original pigment. However, some manufacturers still use the original pigment – PBr7 – but these colours tend to be duller and less orange in hue than the PR101 pigment. For this demonstration I used the synthetic PR101 version as I prefer its cleaner hue.

COLOUR MIXING CHART

1 Burnt sienna pigment is a rich, red brown when applied densely, but used thinly it will give an interesting range of clear tans.
2 Some clarity is lost when mixed with a white. The tints becoming chalky.
3 Lemon yellow produces a clean, transparent orangey-brown.
4 Vermilion hue is a transparent, orangey-red that mixes to make an autumnal brown.
5 Greenish raw umber takes the sting from burnt sienna to create a deep brown, resembling burnt umber.
6 Greenish coeruleum and burnt sienna make a range of grainy browns and greys. The dusty quality increases as more of the opaque blue is added.

Burnt Sienna Mixing Chart

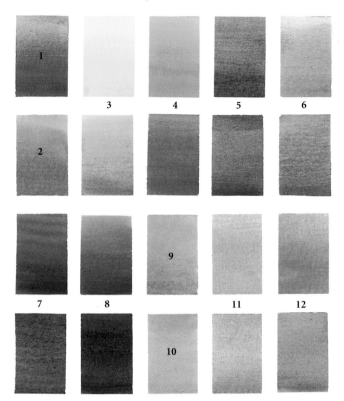

7 Phthalocyanine blue (phthalo/monestial/Winsor) has a greenish bias which, if mixed with burnt sienna, gives a very useful range of neutral, clear, dark grey-greens and browns.
8 The purple bias of French ultramarine is countered by the orangey leanings of burnt sienna, but still there is an under-glow of dull purple.
9 The last two colours used fairly densely gave quite dark mixes. In pale tints they make a range of useful greys. This one is mixed using phthalocyanine blue.
10 Another pale grey, different but equally useful, is made using French ultramarine with burnt sienna. Many watercolourists use this mix for clouds.
11 Cobalt green is a pale and weak colour, but by adding small amounts of powerful burnt sienna, delicate grey-green and brown neutrals result.
12 Cobalt violet (cobalt magenta) too, has a delicacy. Mixing it with a small amount of burnt sienna gives an unusually hot, neutralized violet.

PROPERTIES
PERMANENCE: ASTM D4302 Class I (excellent lightfastness); Blue wool scale 8 (absolutely lightfast).
COLOUR BIAS: Orange-red.
TRANSPARENT/OPAQUE: Transparent.
STAINING: No.
HAZARDOUS: Not considered hazardous.
TINTING STRENGTH: Medium.
CHARACTERISTICS: Versatile, it makes good greys with ultramarine and rich, useful greens with the cold phthalo or viridian green.
WATERCOLOUR: A superb grainy, transparent, orange or reddish-brown.
OIL: Good in thin layers where its glow and transparency are effective. It has a medium to high oil absorption and is a medium to fast drier, giving a hard, fairly flexible paint film.
OTHER MEDIA: Burnt sienna is used in all other media.

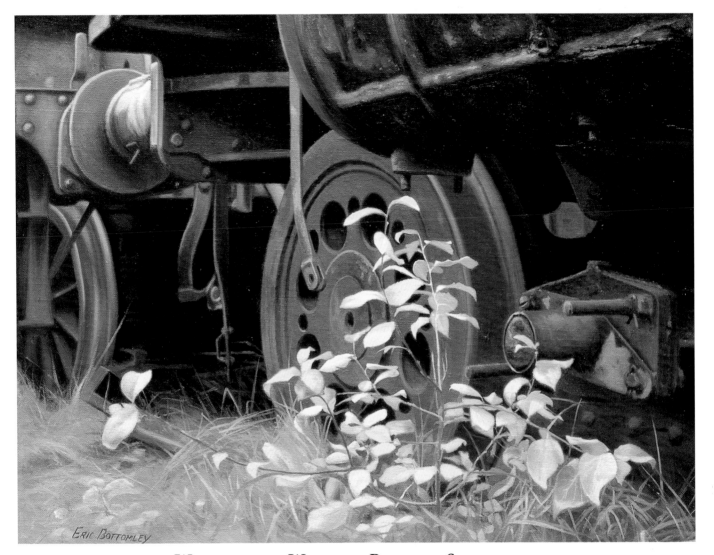

WHEELS AND WEEDS – RAILWAY SCRAPYARD
ERIC BOTTOMLEY
oil on canvas; 355 x 508mm (14 x 20in)

The rusty hue of burnt sienna is perfect for the corrosion on the locomotive wheels. In parts, alizarin crimson was added to sharpen the colour, and for the bare earth, yellow ochre was mixed with the sienna. The charcoal grey of much of the metalwork is a burnt sienna/ultramarine mix, with a little white. Coeruleum, rather than ultramarine was used in the light greys. The greens are mixes of ultramarine with lemon yellow, cadmium yellow or yellow ochre and the deep darks are ultramarine and burnt sienna.

MARS VIOLET (Caput Mortuum) — Pigment Red 101

ORIGINS

This colour is based on mars yellow which has been roasted in the oven. The literal meaning of *caput mortuum* is "death's head" – a skull – but the term was used by alchemists to designate the "worthless residue" in a flask after distillation was complete.

Whatever the origins of the name, the pigment has no grisly associations and is certainly not a "worthless residue", being a reliable and absolutely permanent colour, useful in both landscape and portrait work. However, it is not a colour to send you, in eager anticipation, to your local art shop. The dull brownish-violet – a bluer version of Indian red – is best used in dilutions with white. It is a superb pastel colour, especially in the paler tints, or in mixes with other colours.

COLOUR MIXING CHART

1 Mars violet veers more to blue than Indian red, but it is by no means truly violet in hue, as its name suggests.
2 Adding white to mars violet cools it slightly, bringing out its bluish undertone. An ideal colour for shaded flesh in portrait work.
3 The sunny gamboge hue reacts well with mars violet to produce a soft, suede brown, quite dusty in character.
4 The warm dullness of raw sienna is sharpened by adding mars violet. The resulting colour is a little redder and certainly more granular.
5 Cadmium red's livid brightness is subdued to a dull glow by adding mars violet. The resulting hue resembles Indian red.
6 The bluish undertones of the sharp, purplish, permanent rose and mars violet combine to create a cool, dull burgundy. Although the hue is rich, it has a soft quality.
7 Grainy coeruleum combines with mars violet to make a lovely soft greyish colour. Adding more of one or the other colour will give a purplish-grey or a deep, dull plum colour.

Mars Violet Mixing Chart

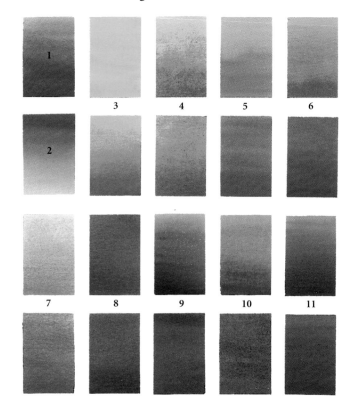

8 The purplish undertones of both French ultramarine and mars violet combine to produce a deep and full, dull purple.
9 The dense and powerful phthalo/monestial blue is neutralized by adding mars violet. Depending on the quantities of the component colours, a soft, deep blue or a greyish, deep brown will result.
10 The vicious sharpness of viridian is killed by adding mars violet. The result is a range of dark, dull and grainy winter greens, ideal for landscape work.
11 Permanent magenta (dioxazine violet) combines with mars violet to make some really rich, dull purples.

PROPERTIES
PERMANENCE: ASTM 4302 Class 1 – excellent lightfastness; Blue wool scale 8 (absolutely lightfast).
COLOUR BIAS: Towards blue.
TRANSPARENT/OPAQUE: Opaque.
STAINING: Slightly.
HAZARDOUS: Not considered hazardous.
TINTING STRENGTH: High.
CHARACTERISTICS: A strong, reliable earth colour of more use in pastel and oil than in watercolour.

WATERCOLOUR: The opacity of mars violet limits its usefulness in watercolour. Even in vast dilutions it will appear as a superimposed layer, which may not sit too well with transparent colours.
OIL: An excellent oil colour, particularly in tints with white. It can produce a range of dusty pinks that beautifully represent flesh in shadow, in portrait work. Mars violet has a medium oil absorption and drying speed. The paint film is hard and fairly flexible. It can be used in any of the layers in a painting.
OTHER MEDIA: Mars violet is suitable for use in all other media.

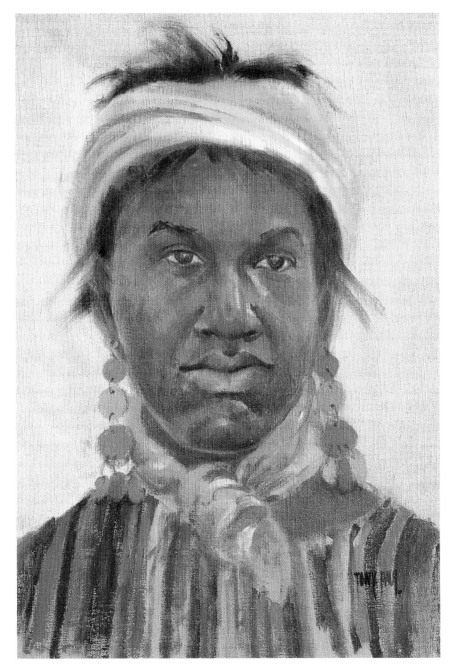

AYOADE, A NIGERIAN GIRL
TONY PAUL
oil on board; 300 x 240mm (12 x 9in)

The pivotal colour of this oil sketch was mars violet. I first put in the facial shadows using this colour fairly straight, but adding a burnt sienna/yellow ochre mix for the forehead and cheeks with a little of the same in the centre of the chin. To get the darker and cooler chin areas, I subdued permanent mauve with a little mars violet. The lights on the face were made by mixing coeruleum with a touch of mars violet and some white. A darker mix of this colour was used for the greys of the upper lip and sides of the cheeks. A blend of burnt sienna and cadmium red was touched in to warm the inner cheeks and the underside of the nose. The dark hair, eyebrows, nostrils and mouth line were drawn using a mix of burnt sienna and ultramarine.

LIGHT RED — Pigment Red 102

ORIGINS

There can be confusion about red-browns. Some veer towards yellow or purple in undertone. They are known variously as light red, English red, Venetian red, red iron oxide, Indian red, mars red, caput mortuum etc. The first three have an undertone veering to yellow, while the remainder have a distinctly purplish bias. Even so, one maker's Indian Red may be like another's light red. They are all iron-rich yellow clays which have been roasted until they achieve the benchmark colour required by the pigment maker.

The ASTM will only name a pigment "light red" if a genuine yellow ochre has been roasted to give a yellowish, browny-red. Even within this category the actual shade of the colour will vary from maker to maker, depending on the source of the original pigment.

COLOUR MIXING CHART

1 From this sample we can clearly see the yellowish undertone of light red.

2 This colour is Indian red – see how purplish it is compared to light red.

3 When white is mixed with light red it undergoes a temperature change, becoming cooler and bringing it closer in colour to Indian red.

4 Adding the sunny cadmium yellow to light red makes an autumnal orange-brown.

5 Grainy yellow ochre – the raw pigment from which light red is made – mixes to give a slightly duller orange-brown. The granular character of the mix gives it great character.

6 A dull, hot red is made from cadmium red and light red.

7 The purplish bias of alizarin crimson argues with the yellowish undertone of light red to make a more muted deep red. The dusty character is because of light red's opacity.

Light Red Mixing Chart

8 Permanent mauve (dioxazine violet) mixes with light red to create a range of lovely burnt violet colours, ideal for landscape work.

9 If you need a dusty grey, either leaning to a pinkish-brown or a blue slate colour, a mix made from French ultramarine and light red should suffice. The more light red that is added, the dustier the colour will appear.

10 A range of unusual and beautifully subtle colours can be made from the granular coeruleum blue and light red.

PROPERTIES
PERMANENCE: ASTM D4302 Class 1 (excellent lightfastness); Blue wool scale 8 (absolutely lightfast).
COLOUR BIAS: Towards yellow.
TRANSPARENT/OPAQUE: Varies between semi-opaque to opaque.
STAINING: Some varieties can stain a little.
HAZARDOUS: Not considered hazardous.
TINTING STRENGTH: Medium to high (synthetic versions are more powerful).
CHARACTERISTICS: A popular and dense red-brown, used more in watercolour than in other media, despite its opacity.

WATERCOLOUR: Judged with burnt sienna it is difficult to know why both would be needed as they are similar colours. As burnt sienna is the more transparent I would prefer it to light red. But there is a strong following for light red among watercolourists.
OIL: The iron content ensures that light red has a reasonably fast drying speed and the paint dries to form a hard, fairly flexible paint film, with a low to medium oil absorption. It would be suited to the under-layers of a painting – excellent for roughing in an under-painting or toning a canvas.
OTHER MEDIA: The inert nature of light red means that it is suitable for use in all media.

11 The dense, rather bland oxide of chromium green combines with light red to produce some superb landscape colours. In watercolour it is wise to use this mix as an under-colour rather than as an overlaid wash because it is opaque.

12 Although oxide of chromium and viridian are close relatives they have entirely different characters. Viridian is cold, veering towards blue in undertone. This argues with the yellow leaning of light red to make a fairly neutral and granular range of damp, winter greens.

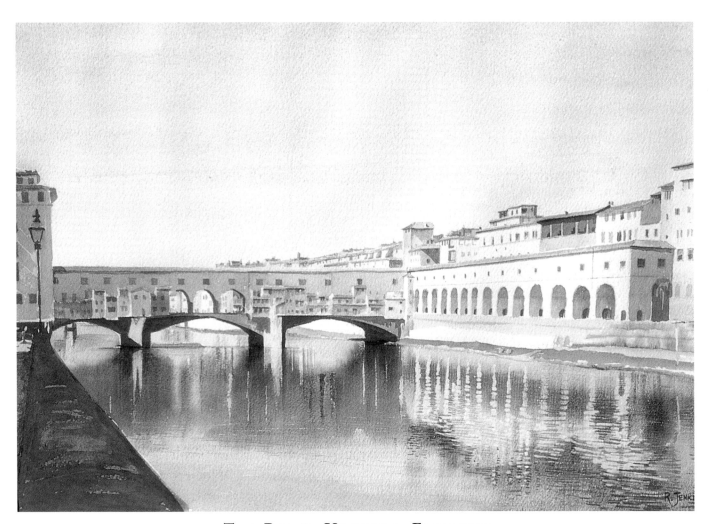

THE PONTE VECCHIO, FLORENCE
ROD JENKINS
watercolour, 300 x 450mm (12 x 18in)

Only four colours were used in the painting – light red, raw sienna, ultramarine blue and phthalo blue. The sky was underwashed with raw sienna which, when dry, was overlaid with a gradated wash of ultramarine. Varying mixes of raw sienna and light red were used for the buildings, with shadows created from light red and ultramarine. A small amount of phthalo blue was combined with raw sienna for the grass of the riverbank. Highlights on the water were masked out with masking fluid and the water and reflections painted in mixes of raw sienna, light red and ultramarine. When this was dry, the masking fluid was removed and the whole water area was washed over with raw sienna.

INDIAN RED – Pigment Red 101

ORIGINS

Originally a historic natural red ochre earth imported from India, now it is made from the excellent synthetic iron oxides. These are finer ground and more powerful and consistent in hue than their natural counterparts. Against burnt sienna it appears quite bluish and is useful in mixes with blues for creating shadows. Although it is quite densely opaque, it can successfully be used in pale washes in watercolour, but would be better used as an under-colour, rather than a superimposed wash. In oil, acrylic, pastel and egg tempera its opacity is not a problem and it is superb.

COLOUR MIXING CHART

1 Indian red has a smooth, dense, deep purplish-brown hue.
2 Adding white cools the colour considerably, bringing out the purplish undertone of the colour and giving a very smooth finish.
3 Cadmium yellow pale mixes with Indian red to create a soft ochre-tan which is slightly dusty in character.
4 The hue of the cadmium yellow deep/Indian red mix is fuller and warmer – a good autumnal colour.
5 The mix with raw sienna is softer and cooler – another good subtle colour for autumnal landscapes.
6 Indian red takes the brightness out of cadmium red, yet retains its heat to make an unusual red-brown.
7 The tone of alizarin crimson is deepened and dulled by adding Indian red. Again, a good autumnal colour.
8 Permanent mauve (dioxazine violet) mixes with Indian red to make a very unusual purple brown – a good shadow colour for warm, ochre landscapes.
9 When well-diluted, the combination of grainy coeruleum and Indian red makes a grey that is almost lilac in hue.
10 Ultramarine and Indian red make a subtle purplish-grey. In pale dilutions or mixed with white, this mix is good for shadowed cloud.
11 The sharp quality of phthalo green is subdued by Indian red to make a useful and versatile landscape green.

Indian Red Mixing Chart

PROPERTIES

PERMANENCE: ASTM 4302 Class 1 (excellent lightfastness); Blue wool scale 8 (absolutely lightfast).
COLOUR BIAS: To purple.
TRANSPARENT/OPAQUE: Opaque.
STAINING: No.
HAZARDOUS: Not considered hazardous.
TINTING STRENGTH: High.
CHARACTERISTICS: A versatile purplish earth colour, ideal for shadows in both landscape and portrait work. Despite its opacity it is one of my favourites in watercolour as well as all the other media.
WATERCOLOUR: Gives a fine, even wash which is densely opaque at full strength, so it will appear as an obliterating overlay. However, when it is diluted or washed down into a dilute wash it makes wonderful subdued pinks that veil rather than obliterate under-layers.
OIL: An excellent underpainting colour, being of medium oil absorption and a medium drier. The dry paint film is hard and fairly flexible. It can be safely used in both upper and lower layers of a painting.
OTHER MEDIA: I particularly like its use in tempera. As you will see in the painting opposite, it makes lovely purplish greys when mixed with ultramarine and white. It is wonderful in all media – one of the best colours.

ONE "M" OR TWO?

TONY PAUL

egg tempera on gesso panel; 300 x 250mm (12 x 10in)

Indian red was used in mixes throughout this painting. The shaded side of the face was made with a mix of Indian red and ultramarine, reduced to a pale tint with white. A similar colour was used in the shadow around the right eye. A darker mix of this colour was used in the arms and hands and a blue-heavy blend used for the corduroy dungarees. Indian red was added to burnt umber to cool certain areas of the shirt and in mixes with cadmium red, alizarin crimson and cadmium yellow in the hair and in the sponged background. The creamy complexion of the right side of the face was made from cadmium yellow deep and cadmium red with a lot of white added. The blue of the dictionary was ultramarine with Indian red.

GREENS

RIGHT Farm at Chenonceau, Loire Valley; *watercolour; by Tony Paul. The sky is manganese blue, the greens made from green gold mixed with either coeruleum or ultramarine. Strong darks are made from burnt umber and phthalo green. The building is green gold, ultramarine and burnt umber, all wet-in-wet. The roofs of the lean-to and the well were painted in burnt sienna.*

VIRIDIAN GREEN – Pigment Green 18

ORIGINS

This vivid blue-green originated in France in 1838. Its introduction more or less made the older and less reliable verdigris and malachite green obsolete.

COLOUR MIXING CHART

1 The raw viridian is harsh, cold and an unnatural green. It is of limited use unmixed.

2 Mixing white with viridian produces quite a pleasant, but still unnatural looking pale green. A very pale green can be useful in small touches for cold highlights on vegetation.

3 In the gradated viridian/lemon yellow mix, see how the greenish bias of the yellow contributes to the bright acidity of the mix. A clean colour, useful in spring landscape, but don't overdo it as it can be extremely raw. A little goes a long way.

4 A useful, soft green is achieved with raw sienna and viridian. The mix is quite grainy but perfectly suited to landscape work.

5 An equal mix of cadmium red and viridian is a neutral purplish-grey but, when green heavy, it makes useful landscape greens with a crimson undertone. As cadmium red is an opaque colour, this further dulls the result. This is because the colours are opposites in the colour wheel and therefore tend to neutralize each other.

6 Autumnal greens can be created with burnt sienna. An altogether warmer colour than that made from cadmium red, the two transparent pigments combine to make a rich hue.

7 The greenish bias of raw umber combines with viridian to give a sharper green. Decidedly wintry, it suggests damp, mossy trees and shadowy evergreens.

8 Still in wintry mood, burnt umber with viridian.

Viridian Green Mixing Chart

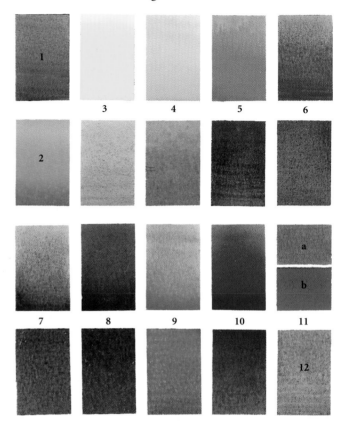

The green is softer but still very neutralized by the warm brown.

9 Mixing viridian with a green biased blue, such as coeruleum, can give a Mediterranean blue – bluer or greener – depending on how much of each colour is added.

10 For a deep sea blue-green, use a mixture of viridian and French ultramarine. The purplish bias of the blue means that the resulting colour will not be as sharp as if

PROPERTIES

PERMANENCE: ASTM D4302 Class 1 (excellent lightfastness); Blue wool scale 7 (absolutely permanent).

COLOUR BIAS: Towards blue.

TRANSPARENT/OPAQUE: Transparent.

STAINING: No.

HAZARDOUS: The modern colour is not considered hazardous. Older colours, produced since 1978, will have a hazard warning symbol if they contain any hazardous substances. For a tube or pan that pre-dates 1978, it would be wise to treat it as having a hazardous element.

TINTING STRENGTH: The low side of medium.

CHARACTERISTICS: Many experienced artists use viridian a lot, usually in mixtures. It is an expensive pigment and in student ranges is substituted by a "hue" (normally

phthalocyanine green). Despite the real pigment's weaker tinting strength, many painters prefer its quieter nature.

WATERCOLOUR: The transparency of viridian makes it ideal for watercolour and its versatility makes it a must. For lift-out techniques it is best to use non-staining viridian rather than strongly staining phthalo green.

OIL: Viridian is a good colour in oil. Being transparent, it is excellent for glazes, but unmixed in impasto it is a blackish colour, more dead than alive. It has a very high oil absorption and should not be used unmixed in under-layers of a painting. Viridian has a medium drying speed and when dry gives a hard and fairly flexible paint film.

OTHER MEDIA: Viridian pigment is not compatible with acrylic paint, usually being substituted by phthalocyanine green.

it were mixed with a green biased dark blue such as phthalo or Prussian blue but it will be subtle.

11 This rectangle shows the difference in hue between true viridian (a) and the phthalocyanine green pigment (b) which is usually used as "viridian hue" for student colours. Note the sharper, cleaner colour of the substitute pigment.

12 The cool, reddish tone of cobalt violet (cobalt magenta) conflicts with viridian to produce a cold greyish colour. Useful for winter scenes.

GONE FOR LUNCH
TONY PAUL
egg tempera on gesso panel; 500 x 600mm (20 x 24in)

All greens in this painting are of viridian mixed with raw sienna, burnt sienna or burnt umber. In some areas the viridian was cooled and softened with coeruleum and white. Light colours were applied over darker underpainting to give depth to the rough grass. The meadow is raw sienna and white, while the distant trees are coeruleum, viridian and raw sienna, well diluted with white. The shadow areas of the chairs were painted in a dappled mix of coeruleum, alizarin crimson and raw sienna, all softened with white.

OXIDE OF CHROMIUM – Pigment Green 17

ORIGINS

This pleasant, but rather bland grey-green is a close relative of viridian. The raw materials are the same but oxide of chromium is roasted. This makes the colour opaque unlike its transparent sibling. It should not be confused with the now obsolete and flawed chrome green, which was a mixture of the dubious chrome yellow and Prussian blue. Invented in the early 1800s, it was introduced into the artist's palette in 1862. Because of its rather bland colour and fairly low tinctorial strength it has never enjoyed the popularity of the other greens. It does, however, make some interesting mixed colours.

COLOUR MIXING CHART

1 The pigment is quite densely opaque but will wash down to give translucent, rather than transparent, effects.

2 When mixed with white the slight yellowish undertone disappears and the colour goes a little greyer in hue.

3 Adding lemon yellow cheers up the dull grey character of the green a little.

4 Substituting the sunnier gamboge hue for the paler yellow warms the mixture considerably. The colour is still relatively dull, but useful.

5 The strongly granular character of raw sienna gives a characterful mix. A useful autumnal, "leaves on the turn" green.

6 Mixing opposites in the colour circle will give a quite neutral colour. Cadmium scarlet opposes oxide of chromium. A half and half mix will give a brown. Add more red and it glows dully, add more green and it becomes a dusty, darkish brown – quite useful.

Oxide of Chromium Mixing Chart

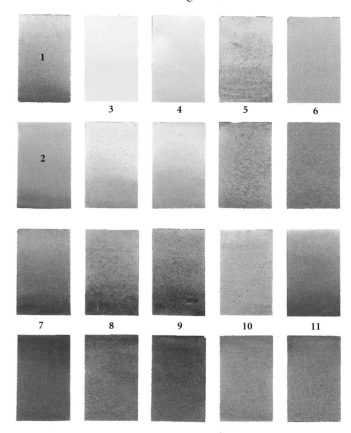

7 The cooler alizarin crimson relates to the coolness of the green to give a dull purplish colour, veering to dark grey as more green is added.

8 Forever autumn – mixing burnt sienna with this green gives superb autumnal colours. Quite granular in watercolour and the mix will be opaque if it is loaded heavily with the green.

PROPERTIES

PERMANENCE: ASTM 4302 Class I (excellent lightfastness); Blue wool scale 8 (absolutely lightfast).

COLOUR BIAS: A yellow-grey undertone.

TRANSPARENT/OPAQUE: Opaque.

STAINING: Slightly.

HAZARDOUS: The modern colour is not considered hazardous. Older colours, produced since 1978, will have a hazard warning symbol if they contain any hazardous substances. For a tube or pan that pre-dates 1978, it would be wise to treat it as having a hazardous element.

TINTING STRENGTH: Medium.

CHARACTERISTICS: A pleasant green which lacks versatility. Its muted quality makes it a popular "straight from the pot" colour with beginners, but it usually gets boring when used this way. It is often neglected as a mixing colour and ends up consigned to the bottom of the "spare colours" box. Because the pigment is densely opaque it imparts a dusty character to some mixed colours.

WATERCOLOUR: Its limited effect, low tinting power and opacity make it a less popular choice than other greens. In mixes it can be very useful, and is also handy, unmixed, for the odd touch, rather than as a main colour. It is lightfast and gives a fine granular effect. The pigment is very heavy and will separate out in washes mixed with lighter weight pigments, giving some quite interesting textures.

OIL: Its low oil absorption and medium drying speed make it an ideal colour to use in the under-layers of a painting. It dries to give a hard and fairly flexible paint film. Its apparent lack of versatility reduces its popularity.

OTHER MEDIA: Can be used in all media except in pastel, where the original pigment will be replaced by a hue colour.

9 Extending our autumn range, the burnt umber gives colder, subdued greeny-browns.

10 Oxide of chromium subdues the sky blue coeruleum to give a range of grey-greens, useful for reflected light in shadowed foliage.

11 A dusty grey-green results from mixing the green with French ultramarine. This mix is excellent for cool shadows. The more green that is used, the dustier the colour will appear. Transparent ultramarine heavy mixes will be cleaner in character.

A MOROCCAN GOATHERD
TONY PAUL
watercolour; 280 x 380mm (11 x 15in)

All the greens in the painting were made from mixes with oxide of chromium. The darker greens were made with additions of ultramarine, Indian red or burnt sienna, while the middle greens were pure oxide of chromium. The lighter greens were mainly mixes with lemon yellow with some raw sienna dropped in wet-in-wet and the tree trunks were burnt sienna and ultramarine. The sky was manganese blue and the Atlas Mountains in the background, dilute Indian red and ultramarine. The goatherd's clothing was a mix of oxide of chromium and ultramarine and the earth a wash of raw sienna overlaid with Indian red and vermilion hue. The goats were mixes of either Indian red or burnt umber with ultramarine, and the shadows generally Indian red and ultramarine.

TERRE VERTE – Pigment Green 23

ORIGINS

Terre verte, "green earth", is a historic pigment that varies in colour from source to source, but is usually a greyish-green. It was essential in the 13th, 14th and 15th centuries, always being used to under-paint flesh. One only has to look at the grey-green faces of the Madonnas of Duccio to see the colour in use. This was not how Duccio intended us to see the flesh colours, but over the centuries the red lake that originally covered the terre verte under-painting has faded. The pigment is weak and has a strange texture. I use it in my egg tempera paintings and find it tricky to use as it will not brush out smoothly. Many manufacturers add other pigments to the original pigment to strengthen its power and make it easier to use. Daler-Rowney do not use the true pigment, but produce a hue made from iron oxide and viridian.

COLOUR MIXING CHART

1 Unmixed terre verte gives a granular and streaky wash in watercolour. Both in its unmixed state and in mixes, the colour makes a wide range of muted, useful colours, particularly for landscape work.

2 Mixing almost any colour with terre verte improves its handling. Mixed with white gouache, the temperature of the original colour is made cooler and greyer in hue.

3 Adding lemon yellow softens and warms the green. The greyish character is, at the same time, subdued.

4 Grainy raw sienna and terre verte create a mix that almost smells of damp woods. There is probably enough flexibility to paint a successful landscape using only these two colours in various proportions.

5 A dusty, dark grey can be made by adding a small amount of cadmium red to terre verte.

6 A mix with a similar character to no. 4, but with more of an autumnal feel, can be made with burnt sienna.

7 The mixing of coeruleum with terre verte gives a useful but slightly dirty colour. The opacity of the blue gives the colour a dusty look.

Terre Verte Mixing Chart

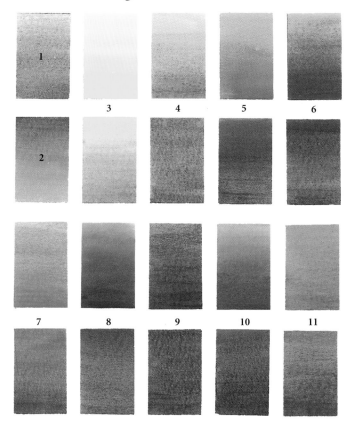

8 Phthalocyanine blue gives a similar, but slightly sharper and cleaner colour. This is because both component pigments are transparent.

9 A damp browny-grey results from raw umber with terre verte. The mix has a pronounced grainy quality in watercolour.

10 An unusual, dull, blackish-violet is made by mixing permanent mauve (dioxazine violet) with terre verte – useful for deep shadows.

11 Another naturally granular colour – viridian – combines with terre verte to create a dank, dull winter green.

PROPERTIES
PERMANENCE: ASTM D4302 Class 1 (excellent lightfastness); Blue wool scale 7 – 8 (absolutely lightfast).
COLOUR BIAS: Blue-grey.
TRANSPARENT/OPAQUE: Transparent.
STAINING: No.
HAZARDOUS: Not considered hazardous.
TINTING STRENGTH: Very low.
CHARACTERISTICS: Excellent for underpainting flesh in water-based media, particularly in tempera. Modified, it can work well in watercolour washes.

WATERCOLOUR: Don't expect smooth flat washes from this pigment. The washes are streaky and granular, but used with care in landscape, it can prove very useful.
OIL: Its low tinting power and high oil absorption make it of limited value in oil painting. It dries slowly to give a soft, flexible paint film. Probably best used as a modifying glaze in upper layers of a painting, but its innate streakiness is difficult to overcome.
OTHER MEDIA: Compatible with all other media but often left out of all but artists' oil and watercolour ranges.

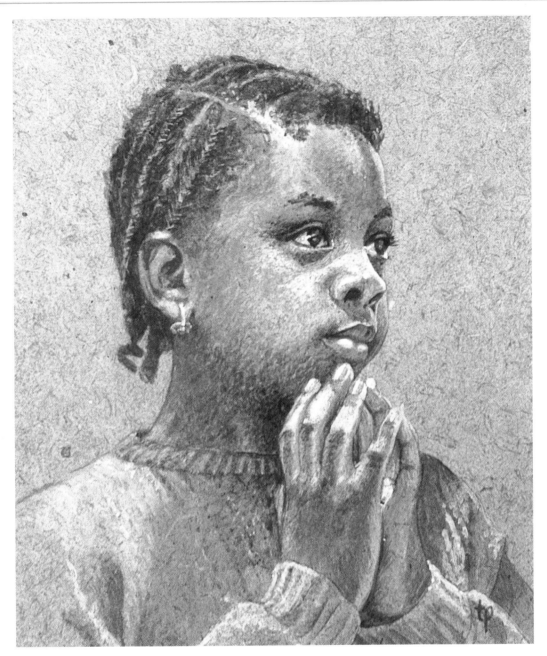

JAMAYA
TONY PAUL
egg tempera on hardboard; 170 x 140mm (7 x 6in)

I liked the colour of the hardboard and wanted it to contribute to the painting so
I primed the board with transparent acrylic matt medium and used only terre verte,
Indian red, alizarin crimson and white. The green was mixed with Indian red for the
hair and the darker details, while for the flesh colours it was used just with white added
for the highlit areas and unmodified for the shadows. In the deeper shadows Indian
red was added. It goes almost bluish-grey in pale tints and when alizarin is mixed
in, it makes a soft neutral colour. The cheeks were warmed a little with dilute
alizarin crimson which, because of its transparency, was made hotter still by the
underlying colour of the board. There are areas of the face that are just the colour of
the board showing through.

COBALT GREEN AND COBALT GREEN DEEP –
Pigment Green 17 and 26

ORIGINS

Cobalt green became popular following its introduction into the artist's palette in 1835. Its colour is either a delicate, near mint colour or a stronger, darker green. These greens found much favour among Victorian watercolourists. Nowadays the colour is not so popular. There are two reasons for this: firstly, like all cobalt colours, it is expensive. Secondly, it is low in tinctorial power. To achieve even a modest wash, especially with the paler colour, a vast amount of pigment has to be used. It seems at times almost to dissolve into the brush.

COLOUR MIXING CHART

1 Fairly streaky when applied densely, it dilutes to give a grainy, pale blue green.
2 The opaque nature of the pigment means that its character is not changed when white is added.
3 A very delicate spring green results from mixing lemon yellow with cobalt green. Its clarity results from the yellow's fairly neutral bias – it doesn't lean towards orange or green to any extent. Therefore, it reacts with the bluish-green to produce this fresh, delightful colour.
4 The orange leanings of gamboge hue, argues with the bluish character of cobalt green, to give a warmer, but slightly duller, green.
5 Yellow ochre, being a dull yellow, mixes with cobalt green to give a grey-green, quite useful for landscape work. The colour, as with most of the other mixes, exhibits quite a dusty character.
6 The vivid, cadmium red is subdued by cobalt green. The mix turns into a neutral reddish-grey. See how streaky the green goes when applied with the necessary

Cobalt Green Mixing Chart

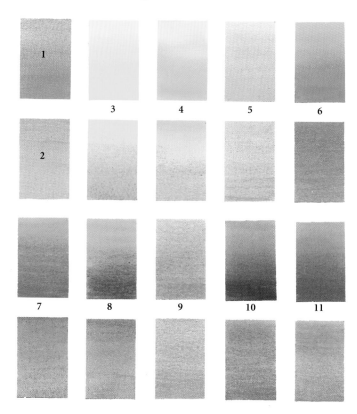

density to compete with the powerful red pigment. Any attempts to brush out the streakiness result in it being instantly overpowered by the red.
7 A frosty, purplish-grey, which I think is rather beautiful, results from permanent rose being mixed with the green. Be careful to add the stronger permanent rose by degrees to the green.

PROPERTIES

PERMANENCE: ASTM 4302 Class 1 (excellent lightfastness); Blue wool scale 7–8 (absolutely lightfast).
COLOUR BIAS: Towards blue.
TRANSPARENT/OPAQUE: Fairly opaque, but even in slight dilution its weakness renders its character more transparent.
STAINING: No.
HAZARDOUS: The modern colour is not considered hazardous. Older colours, produced since 1978, will have a hazard warning symbol if they contain any hazardous substances. For a tube or pan that pre-dates 1978, it would be wise to treat it as having a hazardous element.
TINTING STRENGTH: Very low.
CHARACTERISTICS: Slightly granular, fresh greens, they can be streaky if applied densely. Cobalt green is a unique

colour with a fairly pale mass tone – so you won't get dark mixes, whereas cobalt green dark will give solid greens and darks. Apart from mixed greens, very few of the colours are bright, but are subtle and unusual. Some manufacturers strengthen the pigment by adding other pigments or replace it with a "hue". Check the shade card before buying.
WATERCOLOUR: Probably best used in small, fairly dense, touches or in mixes, rather than in broad washes that can have a faded look (the pigment is, of course, extremely lightfast and one of the least likely colours to actually fade).
OIL: A superb underpainting colour as it is a medium to fast drier and has low oil absorption. The dried paint film is hard and fairly flexible.
OTHER MEDIA: Can be used in all media except in pastel, where the original pigment will be replaced by a hue colour.

8 Most of the heat is taken out of burnt sienna by the green. A grainy and characterful landscape mix.

9 Coeruleum is a close relative of cobalt green and shares its opacity. The result is a grainy, soft turquoise green, ideal for spring foliage in shadow. This would be a good mix in oil where opacity is useful.

10 Algae-covered tree trunks in damp, Northern European woods could be beautifully described by mixing cobalt green with burnt umber. The brown is neutralized almost to grey.

11 A steely grey results from mixing cobalt green with permanent mauve (dioxazine violet). A useful neutral.

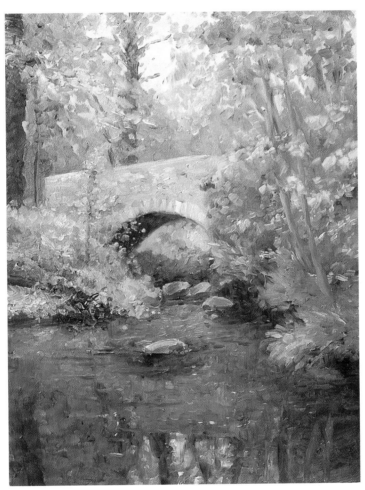

PACK HORSE BRIDGE
TONY PAUL
oil; 400 x 320mm (16 x 13in)

This was painted on a pinkish, tinted board, some of which has been allowed to show through. All the greens were made from mixes involving cobalt green and cobalt green dark, with lemon yellow and cadmium yellow; some mixes with added white. Burnt sienna was added to the darker green to make the darks of the tree trunks and the underneath of the bridge, and the "oily" greens of the water were cobalt green dark with burnt sienna and yellow ochre, again with some white. The sky was coeruleum and white, broken with a touch of yellow ochre.

PHTHALOCYANINE GREEN – Pigment Green 7

ORIGINS

There are many colours that the artist has borrowed from industry and in 1938 phthalocyanine green became one of them. A powerful colour, it also has great transparency and a high degree of permanence. Phthalo green (for convenience I will shorten its name) is one of those pigments which is a mixing colour rather than one to be used "as it comes". Because of its difficult name (pronounced "thalocyaneen") it has been given many aliases by different manufacturers: Winsor green, monestial green, phthalo green, thalo green etc. Perhaps its most general pseudonym is "viridian hue" – used in student ranges. It is in no way inferior to viridian and is many times more powerful.

COLOUR MIXING CHART

1 The power and tonal range of phthalo green is quite evident. In full strength the colour is almost black.

2 The difference between phthalo green (a), and the weaker viridian (b), is clearly evident.

3 Adding white gouache to phthalo green makes it opaque and clearly brings out the bluish bias.

4 A vivid, pale green is achieved by mixing lemon yellow with the green. Ideal for light through foliage in a spring landscape.

5 A rounder, less aggressive green can be made by mixing phthalo green and cadmium yellow medium.

Phthalocyanine Green Mixing Chart

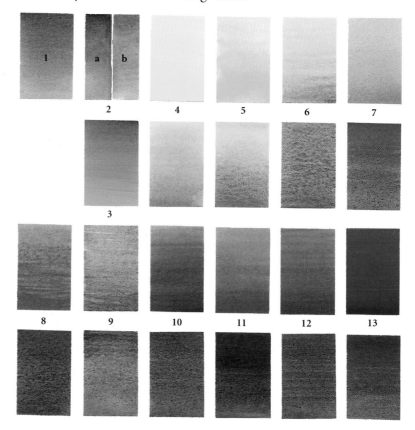

6 The brownish raw sienna gives a subdued green, probably of greatest use in landscape. The sienna gives the mix a grainy character.

7 A combination of vermilion and phthalo green produces colours ranging from a dull rust red to a neutral grey-green.

PROPERTIES

PERMANENCE: ASTM 4302 Class I (excellent lightfastness); Blue wool scale 8 (absolutely lightfast).

COLOUR BIAS: Towards blue. A second version of the colour (pigment green 36), sometimes known as phthalocyanine green – yellow shade, is available in some ranges. In this case, pigment green 7 is known as phthalocyanine green – blue shade.

TRANSPARENT/OPAQUE: Transparent.

STAINING: Strongly staining.

HAZARDOUS: Not considered hazardous.

TINTING STRENGTH: Very high.

CHARACTERISTICS: A blue-green with a wider tonal range than viridian. Its colour too, is cleaner. It is transparent and is a good mixer. Beware – a little goes a very long way.

WATERCOLOUR: A superb transparent colour. It is strongly staining, so use viridian if you wish to use lift-out techniques.

OIL: Phthalo green has a high oil absorption and is medium to slow drying. This makes it more suited to use in the upper layers of a painting. It dries to give a hard and fairly flexible paint film. Thinly applied it is streaky and if thick, appears blackish. Adding a little white will make it slightly more opaque, reduce the streakiness and bring out the colour without significantly altering the depth of tone.

OTHER MEDIA: Phthalo green is suited to all other media. It is always used in acrylic instead of viridian.

8 Burnt sienna is subdued in a mix with phthalo green. Superb landscape browns and greens can be made.
9 Raw umber and phthalo green produce damp woodland greens and browns with a hint of warmth.
10 If winter landscape is a favourite subject, a mix of burnt umber and phthalo green is a must. It gives a stone cold range of greens and browns; subtle yet rich.
11 A series of unusual colours result from mixing with alizarin crimson hue. In mid tones the colour has a dull purplish quality.

12 The reddish component of permanent mauve (dioxazine violet) counteracts the vicious green to produce subtle, neutral dark greens and purples. Ideal for dark areas of winter landscape.
13 The reddish undertone of French ultramarine argues with the green to produce a soft blue-green colour – subtle but full. It is useful for rich darks in a landscape or beautiful deep sea colours in a marine painting. The mix is transparent so under-layers will show through.

LAST OF THE WINDFALLS – ARTIST'S GARDEN
TONY PAUL
gouache; 280 x 300mm (11 x 12in)

After masking out the chair shape, an initial wash of cadmium yellow was applied over the grass area, and phthalo green mixed with burnt sienna applied for the background hedge. These were laid one after the other and at their junction were allowed to blend into a soft edge. The shadows across the grass were phthalo green with less burnt sienna, while darker accents in the hedge were phthalo green with burnt umber. The shadows in the chair were coeruleum and the overhanging branches were painted over the top with the yellow/green/burnt sienna mix, plus white. Detail was added using mixes of all the colours mentioned, with a touch of cadmium red for the apples.

GLOSSARY

ACRYLIC A type of water-soluble artists' colour, made with co-polymer acrylic resin as a binder.

ALKYD A type of artists' oil colour made with alkyd resin rather than linseed oil. Dries considerably faster than standard oil paint.

ALLA PRIMA PAINTING A painting that, once begun, is carried through to its conclusion in one session. Oil painters often say "in one wet".

ARTISTS' QUALITY An artists' colour that is made to the highest standards, suitable for quality, professional work.

ASTM The American Society for Testing and Materials. They have laid down standards for the safety labelling and light-fastness of artists' colours. These have been adopted by most manufacturers throughout the world as the appropriate standards to be used.

BIAS The leaning of a colour towards another colour – for example – cadmium yellow has a bias towards orange, whereas lemon yellow is biased to green.

BINDER The substance that is added to the pigment to make it into a paint so that it will adhere to a painting surface.

BLUE WOOL SCALE A test for lightfastness that compares a specimen colour with specimens of blue dyed wool that fade at a pre-determined rate when subjected to a high intensity light for a period of time. (British Standard BS 1006, EN 20105, ISO 105.)

CHROMATIC TOLERANCE The degree to which primary colours will give pure secondary colours. For example: French ultramarine has a narrow chromatic tolerance as it will make a pure purple but not a pure, bright green; whereas phthalocyanine blue has a wide chromatic tolerance making both bright purples and greens.

C.I. NAME A colour index developed by The Society of Dyers and Colourists and the American Association of Textile Chemists and Colorists to give a universally recognized name for a particular colour. For example: phthalocyanine green is known by a variety of names – monestial green, Winsor green, viridian hue, Stephenson's green, thalo green etc. – none of which mean much. In order to name the actual pigment the colour is first identified – pigment green – this is followed by a number, in this case either 7 (for the blue shade) or 36 (the yellow shade). So, from the C.I. name, Pigment Green 7

(sometimes abbreviated to PG 7), we can identify the pigment as phthalocyanine green – blue shade.

COLOUR TENDENCY See *Bias* above.

COMPLEMENTARY COLOURS Colours that are diametrically opposed in the colour wheel. Red and green, blue and orange, and yellow and violet are complementary colours.

DILUENT A liquid that is used to dilute a paint to a working consistency. Normally this will evaporate completely once the paint begins to dry.

DRYING OILS The oils used as the binder for oil paints, that polymerize to create a dry paint film. The primary oil is linseed, but slower drying, paler oils that yellow less, such as safflower, poppy, sunflower and walnut oil, are used for some high oil colours.

EGG TEMPERA An ancient painting medium which, in its basic form, consists of pigment, egg yolk and water. A minority painting medium in Europe that is more popular in the USA.

EXTENDER An extender, or filler, is an inert substance – often aluminium hydrate, blanc fixe or china clay – that is used to "pad out" the pigment. Extenders are commonly used in student colours to reduce the cost of the colour, improve the structural qualities of a particular colour or to make it opaque.

FAT OVER LEAN When painting in layers in oil painting, each layer needs to be higher in oil content than the preceding one to prevent sinking in and other paint film defects such as cracking. This is sometimes (erroneously) believed to mean "thick over thin". Although this is also good practice in oil painting, thin, oil-rich glazes can successfully be applied over layers of greater thickness that are leaner in oil.

FLOCCULATION In watercolour, a characteristic of French ultramarine in which pigment particles are attracted into minute clots, giving a quality similar in appearance to granulation.

GESSO PANEL The traditional painting surface for an egg tempera painting. It is basically a wooden panel which has been primed with a mix of rabbit skin glue, gypsum or whiting, white pigment and water. Not to be confused with an acrylic gesso primer, which is more suited as a primer for acrylic and oil paintings.

GLAZE Usually relating to oil painting, it is a thin layer of transparent or semi-transparent paint that is applied over previous layers to modify the colour.

GOUACHE A water-based painting medium in which the paint has been rendered opaque either by the addition of an extender or by packing with a large amount of pigment. It is also known as "designers' colour" and "body colour".

GRADATED The way one colour blends into another, darkening or lightening in a progressive, even manner. For example; a watercolour wash of a sky that is darker at the top of the painting and lighter at the horizon is often painted as a gradated wash.

GRANULATION Rather than drying into flat, even washes, some watercolour pigments dry to give a finely speckled appearance known as granulation. Raw umber, burnt sienna, coeruleum and viridian are examples of typical granulating colours.

GROUND A priming that has been applied to a painting surface – usually associated with oil painting.

HARMONIC COLOURS Colours that lie adjacent to one another in the colour circle. For example, yellow and blue are harmonic to green.

HUE This word is used in two ways in this book. Firstly, it is used as another word for colour – "the roof was a reddish hue". Secondly, it is used to describe a colour that has been made to imitate a (usually) more expensive colour – "cobalt blue hue".

IMPASTO Painting with a brush well loaded with paint so that the marks have a three-dimensional character – most often used in acrylic and oil painting.

LAKE COLOURS Colours made from pigments based on dyes. Many of these – purple lake, green lake etc. are likely to have poor lightfastness.

LIFT-OUT TECHNIQUES A watercolour technique whereby parts of a wash are re-wetted and lifted out using a damp brush or kitchen towel – useful for adding small, paler details into flat areas of paint. Care must be taken that non-staining colours are used.

LOCAL COLOUR The actual colour of something seen in a good light and unaffected by shadows.

MASS TONE The tone of a colour when squeezed from a tube or applied thickly.

MARS COLOURS A range of earth colours ranging from yellows to violets that are synthetically made, as opposed to being processed from natural earths. Mars colours tend to be purer, more consistent and brighter in hue, with improved lightfastness.

MEDIUM (PLURAL – MEDIA) A particular type of paint – oil paint, watercolour etc.

MONOCHROME One colour – usually a painting made using various tones of a single colour.

OIL Meaning "oil paint" in painting terms. So-called because the medium used is based on a drying oil.

OIL PASTEL A dry painting medium based on pigment, wax and a fat or drying oil. These are used in a similar manner to soft pastels.

OIL ABSORPTION The amount of drying oil that a particular pigment needs to be ground into to make a structurally sound paint film. Each pigment will have a different oil absorption.

PAINTING MEDIUM A specially made liquid additive to be mixed with a type of paint to improve certain characteristics – eg. a glazing medium.

PALETTE Two meanings; firstly, a surface upon which colours are mixed and secondly, a particular range of colours used by an individual painter.

PASTEL A painting medium based on sticks of pigment, china clay and chalk, bound with the minimum of binder. These are then used in the manner of chalks to make paintings. The pigment is held by the interstices of the paper or board on which the pastel is used.

PB, PBK, PBR, PG, PO, PR, PV, PW, PY Part of the colour index names for pigments – Pigment Blue, Pigment Black, Pigment Brown, Pigment Green, Pigment Orange, Pigment Red, Pigment Violet, Pigment White, Pigment Yellow. The letters are suffixed by a number which indicates the individual pigment.

PERMANENCE The notional effective lifespan of a substance. In painting terms, the lifespan of paintings, pigments,

varnishes, before they deteriorate. Often the permanence of particular colours are tested and rated in terms of lightfastness.

PHTHALO An abbreviation for phthalocyanine – a blue or green pigment.

PRIMARY COLOURS (PRIMARIES) Colours that cannot be mixed from other colours ie. red, yellow and blue. It can also mean colours that are mono-pigments, such as viridian green, which is created green, not a binary mix of blue and yellow.

PRIMING A paint-resisting layer that is interposed between the painting surface and the paint. It has two functions: the first is to prevent deterioration of either paint or painting surface by contamination from the other. The second, to give a good key for the paint.

SATURATED COLOUR A colour applied to give optimum brightness and richness.

SCUMBLE A broken layer of (usually) lighter, opaque colour scrubbed dryly over a darker under-colour.

SECONDARY COLOURS (SECONDARIES) Greens, oranges and purples, produced by combinations of the primary colours, red, yellow and blue.

SHADE A colour darkened (usually) with black. Pastels are made in both shades and tints (paler versions) of the colour.

STUDENT QUALITY An artists' colour that is made to sell at an economical price. This will often mean using either second grade binders and "hue" pigments or using extenders to reduce the pigment content. Some of the substitute pigments may have reduced lightfastness. Student colours are designed for beginners and, of course, students, although some "professionals" use them.

SYNTHETIC IRON OXIDES Earth colours are derived from clays rich in iron. For consistency these are now synthesized and are known as mars colours.

SYNTHETIC ORGANIC COLOURS Pigments made synthetically from blends of organic chemicals.

TERTIARY COLOURS (TERTIARIES) Colours mixed from three colours from the colour wheel. Usually near-greys and brownish colours.

TINCTORIAL POWER (TINTING STRENGTH) The colouring power of a particular pigment. Colours such as Prussian blue are very high in tinting strength, making them very economical in use, little being needed in mixes with other colours. In contrast, cobalt violet has a low tinting strength. A lot of paint is needed to make even a modest pool of colour and in mixes it is easily overpowered.

TINT A colour that has been made paler by the addition of white pigment. (In watercolour the same effect is created by diluting the colour with water).

TONE The degree of lightness or darkness of a colour as compared to a scale from white, through grey to black.

TORTILLON (STUMP) A pencil-shaped stick made of tightly rolled paper, used for blending and consolidating pencil and pastel marks.

UNDERTONE The hue and tone of a colour when thinned. For example, aureolin is a mid-toned putty colour in mass tone, but when diluted is a vibrant pale yellow in undertone.

UNDER-PAINTING A first layer of paint, often applied as a tonal monochrome to establish the basic masses of the painting.

VEHICLE The liquid in which the pigment is applied to the painting surface. It usually consists of a mixture of the paint's medium and a diluent.

WASH A layer of paint, usually watercolour, that is flooded in a consistent, thin veil over an area of the painting.

WATERCOLOUR A colour made from pigment dispersed in a medium based on a water-soluble gum. It is diluted with water and usually applied in a series of transparent washes.

WATERCOLOUR PAPER The usual painting surface for watercolour painting. It comes in three surfaces – rough, hot-pressed and cold-pressed (also known as "not", meaning "not hot pressed") and in various thicknesses designated by weight either in grams per square metre or pounds per ream. 300gsm (140lb) has become the most popular weight, being thick enough not to buckle excessively with wet washes, and economical in price.

WET-IN-WET (WET-ON-WET)
A method of (usually) watercolour painting where further or different colours are dropped into paint that has been applied to the paper, but is not yet dry.

CONTRIBUTORS

Eric Bottomley
The Old Coach House
Much Marcle
Nr Ledbury
Herefordshire HR8 2NL
www.eb-prints.co.uk
High Summer, The Malvern Hills (page 57) and *Wheels and Weeds – Railway Scrapyard* (page 103).

Alwyn Crawshaw
The Hollies
Stubb Road
Hickling
Norfolk NR12 0YS
www.alwyncrawshaw.co.uk

How Much Longer Do We Have To Wait? (page 30, top), *Watery Sunlight* (page 69) and *Taxi! Venice* (page 83).

Charmian Edgerton
18 Beacon Grove
31 The High Street
Carshalton
Surrey SM5 3BA

Ballerina Resting (page 29), *Head of a Ballerina* (page 29), *The Abandoned Boots* (page 38) and *Still Life* (pages 46–47).

Dennis Hill
91 Upton Way
Broadstone
Poole
Dorset BH18 9LX

Edge of a Wood (page 27), *Birds of Paradise* (page 51), *The Mill Pond* (page 63), *Still Life with Bottles* (page 65) and *Keyhaven Boatyard* (page 81).

Rod Jenkins
St Olave's
Fairfield Road
Blandford
Dorset DT11 7BZ
email: olaves@eurobell.co.uk

The Ponte Vecchio, Florence (page 107).

Tony Paul
36 Firs Glen Road
Bournemouth
Dorset BH9 2LT
email: tony@tonypaulart.freeserve.co.uk

All paintings, unless otherwise stated.

Frances Shearing
45 Brackendale Road
Bournemouth
Dorset BH8 9HY

Casa Colonica (page 10), *Brantome, France* (page 53), *Via delle Scale, Volterra, Tuscany* (page 55), *Chickens in the Yard* (page 75), *Windfalls* (page 77), *The Bluebell Wood* (page 87) and *A House in San Gimignano, Tuscany* (page 95).

ACKNOWLEDGEMENTS

This is my first book on painting and I have enjoyed the experience of writing it. However, the production of a book is very much a team effort and I would like to thank the following people who gave tremendous support and practical help:

Firstly, I must thank Rosemary Wilkinson and Clare Hubbard at New Holland, who gave intelligent guidance throughout the writing and to the designer, Ian Sandom, who honed the rough hewn text and illustrations into a well crafted and attractive book.

Another group of people who have been of tremendous help are the contributing artists – Eric Bottomley, Alwyn Crawshaw, Charmian Edgerton, Dennis Hill, Rod Jenkins and Frances Shearing – who have allowed me to reproduce their paintings and given a resumé of the colour mixes used.

Without the persistent requests by the readers of *Leisure Painter* (see details below) I doubt that this book would have been written and I would like to thank editor, Jane Stroud and former editor, Irene Briers for their support.

Daler-Rowney (see details below), in particular Craig Swyer and technical officer Steven Gorse, gave some very practical help by providing photographs and some of the paints used in the paintings, so my grateful thanks to them.

Finally, I thank my ever patient wife Rae, for putting up with things not being done around the house while I was writing this book.

Leisure Painter magazine: for further information and subscription details contact The Artists' Publishing Company Limited, 63/65 High Street, Tenterden, Kent TN30 6BD. Telephone: 01580 763315.

Daler-Rowney, PO Box 10, Bracknell, Berkshire RG12 8ST. Telephone: 01344 424621. Fax: 01344 486511. For full product information, call the customer service team on the above number or visit their website www.daler-rowney.com.

INDEX

INDEX

INDEX

Captions for paintings on pages 2, 3 and 10

Page 2: *The Pink Barn at "Noisy" Dave's*, Tony Paul, egg tempera; 406 x 305mm (16 x 12in)
The main colours used were the earths – raw and burnt sienna, Indian red, burnt and raw umber. The only blue, used with great restraint, was Prussian blue. Other colours were alizarin crimson and titanium white. The barn door is based on burnt sienna with added raw sienna, Indian red and alizarin crimson. The dry grasses were mixed from raw sienna, burnt sienna and raw umber, cooled with Prussian blue. Prussian blue mixed with raw or burnt umber was used for the ground and densely, for the greyish timber, the dark of the barn interior and the grey of the cat.

Page 3: *Old Beehives, Kingcombe*, Tony Paul, egg tempera; 128 x 140mm (5½ x 5in)
The colours used were zinc white, cadmium yellow pale, cadmium orange, permanent rose, burnt sienna, coeruleum, ultramarine and viridian. The background is of dotted layers of yellow, orange and green. These were overlaid with a lightly applied veil of pink, made from permanent rose and white. The lit grasses and foliage are pure cadmium yellow pale, while the darker areas were made from ultramarine and burnt sienna. The hives were painted using coeruleum as a base. The grey weathering was made from viridian and permanent rose with white. Shadowed areas feature greens based on viridian, either warmed with yellow or cooled with permanent rose and ultramarine.

Page 10: *Casa Colonica*, Frances Shearing, watercolour; 330 x 432mm (13 x 17in)
Aureolin, gamboge hue, burnt sienna, ultramarine, vermilion, alizarin crimson and dioxazine violet were used. The wall is aureolin, broken with dioxazine violet and, where warmer, burnt sienna. The shadows are dioxazine violet and aureoline. The warmer greens are of ultramarine and gamboge hue, while the cooler greens use aureolin with the ultramarine. The hard darks are of burnt sienna mixed with ultramarine. The flowerpots vary between blends of burnt sienna with aureolin, vermilion or dioxazine violet. The flowers are various strengths of alizarin crimson and vermilion, with a little ultramarine or violet added here and there for cooler areas.